MANCHESTER SHIP CANAL
THROUGH TIME
Steven Dickens

AMBERLEY

First published 2017

Amberley Publishing
The Hill, Stroud, Gloucestershire, GL5 4EP
www.amberley-books.com

Copyright © Steven Dickens, 2017

The right of Steven Dickens to be identified as the
Author of this work has been asserted in accordance with
the Copyrights, Designs and Patents Act 1988.

ISBN 978 1 4456 3972 7 (print)
ISBN 978 1 4456 3984 0 (ebook)

British Library Cataloguing in Publication Data.
A catalogue record for this book is available from the
British Library.

Origination by Amberley Publishing.
Printed in Great Britain.

About The Author

Steven is from the Flixton area of Trafford and is married to Sarah; they have three sons and three daughters. He is a retired charge nurse and college lecturer, with an academic background in modern history. He has always had an interest in local history and genealogy and has written several journal and magazine articles on these subjects in the past, as well as writing several *Through Time* titles. This volume charts the development of the Manchester Ship Canal from 1894 and its importance to the economic fortunes of the city and port of Manchester. It also looks at development and changes along the full 36-mile course of this Victorian engineering miracle.

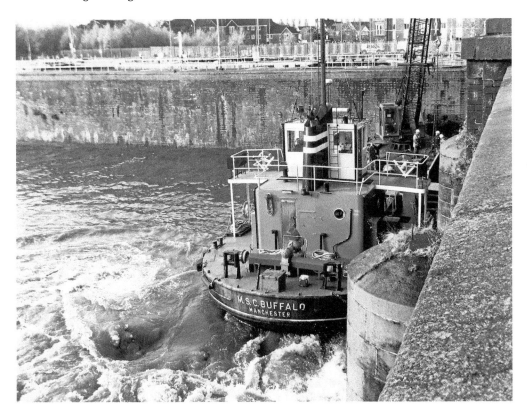

MSC *Buffalo* Assisting Divers at Irlam Locks, November 2016
MSC *Buffalo* is complete with its crane at Irlam Locks, assisting divers while they are repairing and maintaining the sluice gates during a recent episode of heavy rainfall. Although the Manchester Ship Canal is no longer the major economic lifeline that it once was to the city and port of Manchester, it is still an important transport link for the remaining industries along its banks and, as such, maintenance of the canal's infrastructure continues to be a top priority.

Introduction

In June 1882, Daniel Adamson met with members of the Manchester business community, representatives and politicians from nearby Lancashire towns and two civil engineers, with the intention of drawing up and submitting a bill to Parliament for the approval of a canal linking the city of Manchester to the sea. A campaign was undertaken, which was intended to gain public support for the scheme. Fundamental to this campaign was the idea that reduced transport costs to the city would increase the competitiveness of industry and create more jobs. Despite this, the bill was rejected twice due to objections from the Port of Liverpool, but was eventually passed in May 1885, becoming the Manchester Ship Canal Act 1885. It was then the task of the Manchester Ship Canal Co. to raise £8 million worth of shares, in order to cover the cost of constructing the canal, estimated to be at least £5 million.

Once these financial safeguards had been put in place, Thomas Walker was appointed lead contractor, with Edward Leader Williams chief engineer. On 11 November 1887, the first sod was cut by Lord Egerton of Tatton, who had become chair of the company on the resignation of Daniel Adamson. The canal was sectioned into eight separate stretches, with a civil engineer responsible for each one. However, things did not go as smoothly as had been planned and in November 1889 Thomas Walker died, followed by bouts of bad weather and flooding, which led to serious setbacks. By 1891 funding had ceased, with only half the canal project completed. Help was forthcoming in the shape of Manchester Corporation, who approved funding in March 1891, thus avoiding bankruptcy for the Manchester Ship Canal Co. and preserving the city's prestige.

In November 1893 the full 36-mile course of the Manchester Ship Canal was flooded, which then opened for traffic on 1 January 1894. The final cost of the building project totalled over £15 million, equivalent to £1.5 billion today. The canal was officially opened by Queen Victoria on 21 May 1894.

The Manchester Ship Canal became a major economic artery, serving the city and port of Manchester, and indeed the whole north-west of England. It was seen as one of the most ambitious construction projects ever undertaken in the Victorian era. Although it was six years in the making, the benefits to trade and the local economy were very quickly apparent. Manchester became the third largest port in the country, opening up the city to world trade, which reached its peak for the port of Manchester in 1958. However, by the 1970s decline had set in, with the increase in size of ocean-going vessels meaning that they could no longer navigate the ship canal. This fact, as well as an increase in trade with the Far East and mainland Europe, meant that by the early 1980s the port of Manchester had closed and was rapidly becoming derelict. It was given a new lease of life by Salford City Council, who redeveloped the whole docklands area as Salford Quays, now a centrepiece for many iconic architectural structures such as the Lowry Centre and Imperial War Museum North, with new bridges crossing the once bustling port's canal basin.

Although much of the canal traffic has now gone, the canal's infrastructure remains, with historic conservation areas and nature reserves located along its banks for much of

its 36 miles. This is particularly true of Barton, where the world's only swing aqueduct carries Brindley's Bridgewater Canal over the Manchester Ship Canal. In addition, the Barton Swing Road Bridge is here, one of seven located along the Manchester Ship Canal's course. There is also new infrastructure being built along the course of the canal, with the A57 Lift Bridge being constructed, also at Barton, and complementing the Centenary Lift Bridge. At the other end of the canal, the Mersey Gateway Bridge, at Runcorn, is due to open in autumn 2017.

Manchester Ship Canal Through Time will detail all of these historical and modern features, as well as looking at the way the canal has changed and developed over the last hundred years. Its canal traffic, industry, ferries, locks, new development and history will all be charted. I have decided to follow the course of the Manchester Ship Canal from Manchester Docks (now Salford Quays) towards Eastham and the Mersey Estuary. This is purely a decision based on geographical convenience, as I live closer to Manchester and most of my memories of the canal revolve around the Barton Oil Terminal, where my father was employed on the oil tankers that worked the canal. I also found the Barton swing bridges fascinating as a child and was constantly drawn to them, especially when one of the 'big ships' was passing through.

Also relating to Manchester and used throughout the text, you will see 'Manchester Docks', 'Salford Docks', and 'Port of Manchester' all used to mean the same geographical location, that is docks numbered 1–5 at Pomona, 6–9 at Salford and the Trafford Wharf area, opposite docks numbered 6–9. While most of the docks were located in Salford, I have made no attempt to separate these titles, as to do so would be not only time-consuming, but would probably lead to even more confusion! Just to add to this, the main entrance gate to Manchester Docks was located on Trafford Road, in Salford! Suffice to say whichever title is used they all relate to the same location. The final six sets of photographs relate to the iconic Manchester Liners, whose very existence as an economic entity is entirely due to the construction of the Manchester Ship Canal. These vessels were specially built to navigate the dimensions of the Manchester Ship Canal, with all of them registered at the port of Manchester. Their headquarters were moved to the dock complex around 1969, when the company expanded. Despite the company adapting to changing times and introducing containerisation, Manchester Liners' decline came about with the death of the canal in the early 1980s. So inextricably intertwined was the company with the canal that one could not exist without the other. Finally, it only leaves me to say that I hope you, the reader, enjoys my efforts.

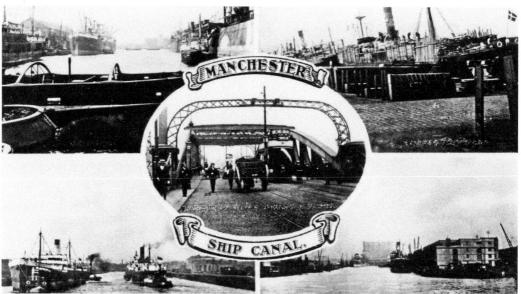

ONE OF THE GREATEST ARTIFICIAL WATERWAYS OF THE WORLD. THIS GIGANTIC VENTURE WAS COMMENCED IN 1887 IN THE FACE OF TREMENDOUS OPPOSITION FROM VESTED INTERESTS AND ALMOST INSUPERABLE DIFFICULTIES, TO BRING A CHANNEL 28 FT. DEEP, 370 FT. WIDE AT THE TOP AND 170 FT. WIDE AT THE BOTTOM, FROM THE SEA INTO THE LAND A DISTANCE OF 35 1/2 MILES ALLOWING THE WORLD'S GREATEST SHIPS TO DISCHARGE THEIR CARGOES IN THE VERY CENTRE OF MANCHESTER. THE COST OF THIS VAST UNDERTAKING EXCEEDED £17,000,000 AND TOOK 7 YEARS TO COMPLETE. A LASTING MEMORIAL TO THE PUBLIC SPIRIT AND TENACITY OF ITS CREATORS. WAS OPENED BY QUEEN VICTORIA 1894

No. 9 Dock and Grain Elevator No. 2 (bottom right), *c.* 1915
The canal runs for 36 miles, from Salford Quays to Eastham Locks on the Mersey Estuary. Shown in the modern image is the old No. 9 Dock at Salford, crossed by the Detroit Bridge. Originally the railway swing bridge, it once crossed the canal near to Trafford Road Swing Bridge. The dock was opened in 1905 by Edward VII and Queen Alexandra and is today split into the Erie Basin, Huron Basin and North Bay, echoing trade destinations of the past.

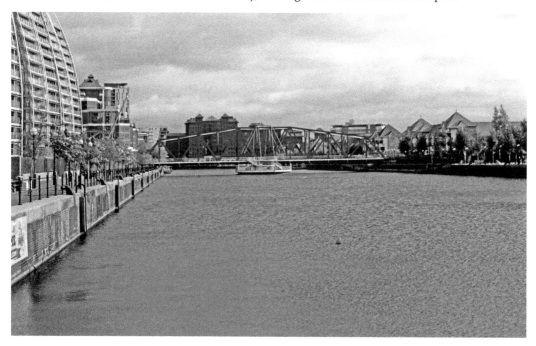

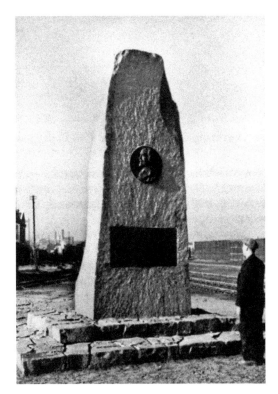

Marshall Stevens Memorial, Junction of Trafford Park Road and Ashburton Road, 1937, and Memorial, Junction of Third Avenue and Eleventh Street, Trafford Park, 2016

This 22-ton block of Welsh granite was designed by Arthur Sherwood Edwards of Ashton on Mersey. It was erected at the junction of Trafford Park Road and Ashburton Road (east) in October 1937. In 1993, it was moved to Wharfside Promenade, now Imperial War Museum North, and then put into storage before relocation to its current site. It reads, 'Marshall Stevens (1852–1936) to whose foresight, energy and ability the successful development of Trafford Park as an industrial area is due.'

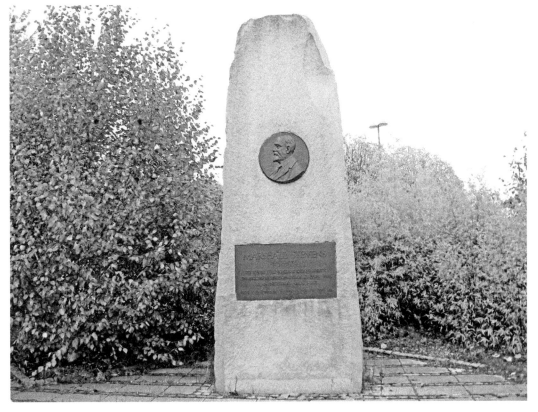

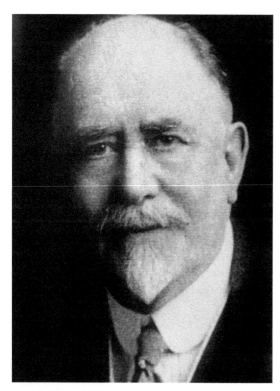

Tomb of Marshall Stevens (1852–1936), Founder of Manchester Ship Canal and Trafford Park Estates, St Catherine's Churchyard, Barton

Marshall Stevens, together with Daniel Adamson and others, was a founder of the Manchester Ship Canal and developer of Trafford Park estates. He was appointed general manager of the ship canal company in 1891. On 1 January 1897, Stevens resigned from the ship canal company to become general manager of Trafford Park Estates, set up by Ernest Terah Hooley to develop Trafford Park into the first and largest planned industrial estate in the world. He was also a Conservative MP for Eccles from 1918–22.

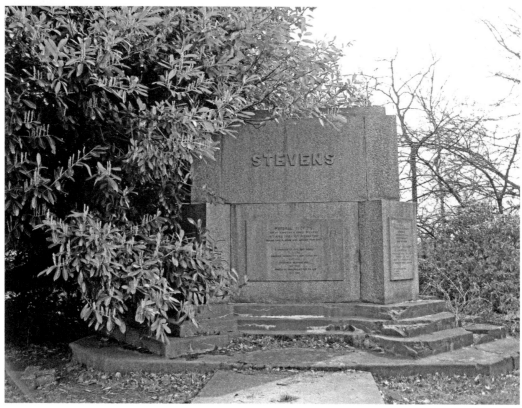

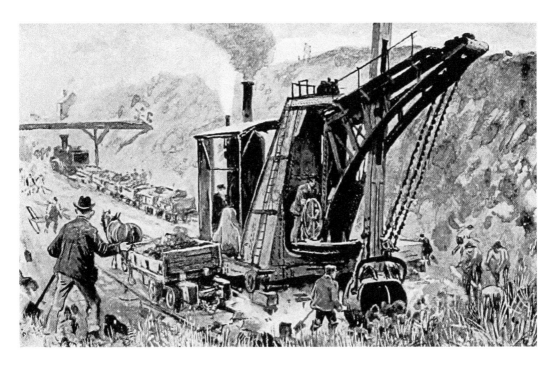

Steam Navvy Excavating and the Construction of the Manchester Ship Canal by 'Navvies', *c.* 1890
The Manchester Ship Canal took six years to complete, at a cost of just over £15 million (around £1.5 billion today). It remains the longest river navigation canal and is the world's eighth longest ship canal. Around 12,000 workers were employed on the canal's construction, which peaked at 17,000 workers. The Grade II-listed structures include the Barton Swing Aqueduct, the first swing aqueduct in the world, and Barton Swing Bridge. In 1909 the canal's depth was increased by 0.61 metres (2 feet), to average 8.5 metres (28 feet).

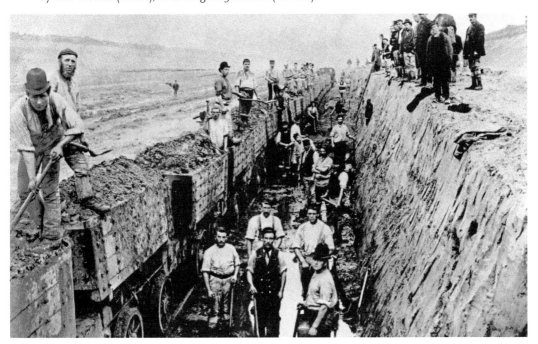

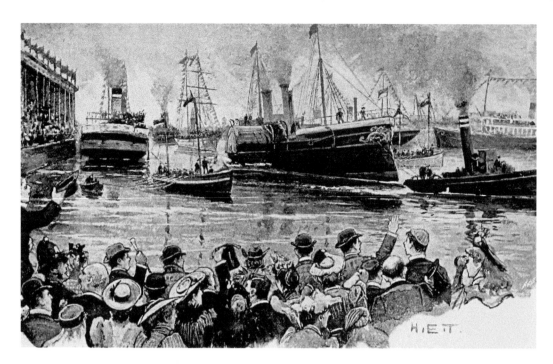

Official Opening of the Manchester Ship Canal by Queen Victoria, 21 May 1894 |
The canal opened on New Year's Day 1894, before Queen Victoria's official visit on 21 May (shown above). At 10 o'clock a procession of vessels, led by Samuel Platt's steam yacht *Norseman*, carrying the company directors, set out along the canal from Latchford. Thousands of cheering onlookers, steam whistles and sirens added to the celebration. *Norseman* was followed by *Snowdrop*, carrying representatives of Manchester City Council and *Crocus*, containing women and directors' friends. *The Pioneer*, a steamer, became the first merchant vessel registered at the port.

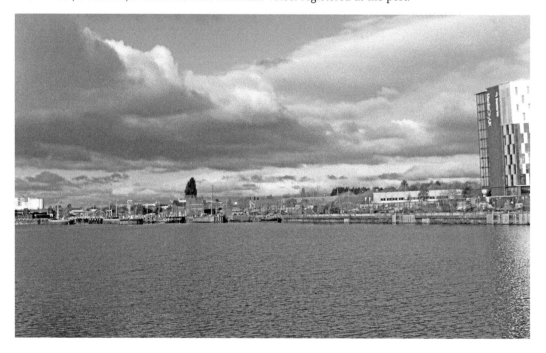

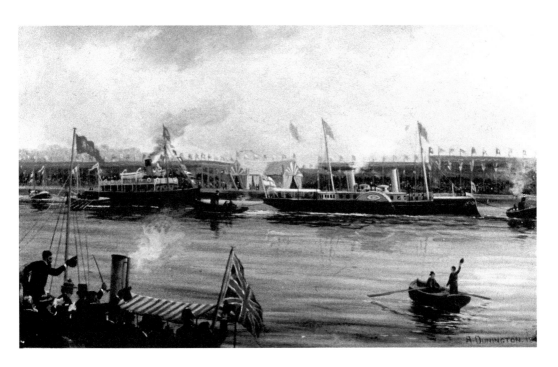

Official Opening of the Manchester Ship Canal by Queen Victoria, 21 May 1894 II
Queen Victoria officially opened the Manchester Ship Canal at Mode Wheel Locks by pulling a cord from her seat in the stern of the royal yacht *Enchantress*. Manchester city centre was decorated for the occasion, with massed crowds cheering and waving. Despite being nearly 40 miles from the sea, the Manchester Ship Canal allowed the Port of Manchester to become the third busiest in Britain. At its peak in 1958, the amount of freight carried by the canal was almost 20 million tons.

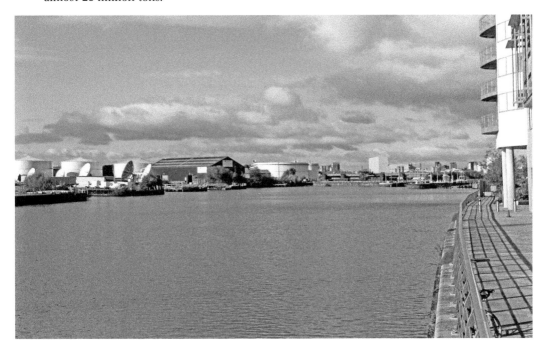

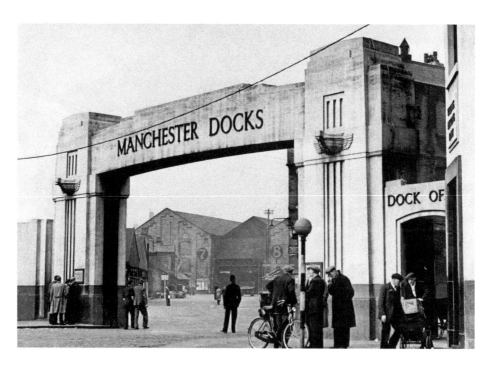

Manchester Docks Main Entrance Gate, Trafford Road, Salford, c. 1950
Above is a view of the entrance gates of the Manchester Docks, next to the former Dock Office (*see* inset), on Trafford Road. No. 8 Dock's warehouses and storage facilities are in the background. The gates are still here today but remain only as a monument to, and in memory of, the past. They now look rather overgrown in comparison to the busy view from around 1950. It originally contained two shuttered gates that could be pulled across the entrance in order to lock it.

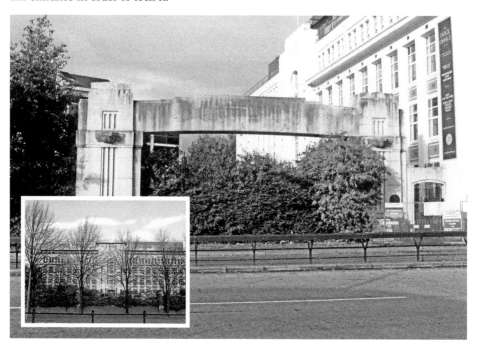

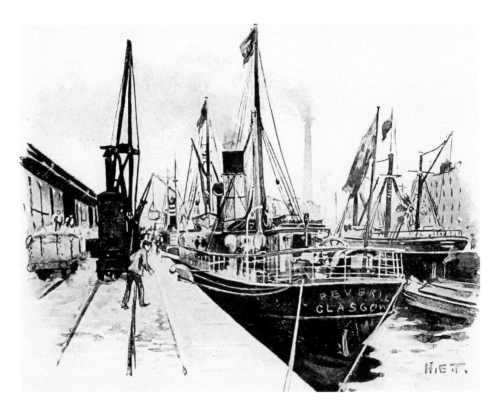

Pomona Dock, *c*. 1894

Further upstream, beyond the Trafford Road Swing Bridge and Metrolink Bridge, were the Pomona Docks. Docks here were numbered from five to one, with No. 5 Dock never fully completed and No. 1 Dock the only dock within Manchester. Today, little evidence remains that there was once a dock complex at Pomona. Huge office blocks of glass and steel now tower above Trafford Road Swing Bridge, which is fixed in place so that the canal is not navigable to larger vessels beyond this point.

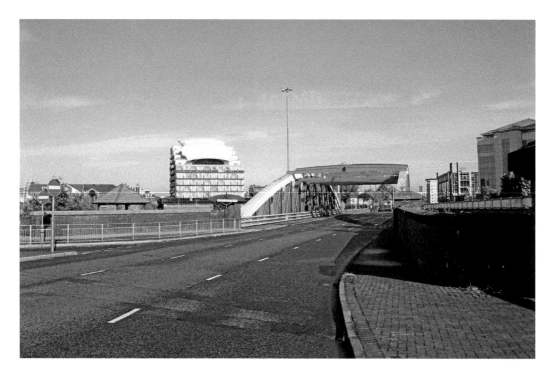

Trafford Road Swing Bridge, *c.* 1900
It was built as a swing road bridge, carrying the A5063 across the Manchester Ship Canal at Old Trafford. This allowed free passage for shipping heading to and from Pomona Docks. When in operation, it could cause lengthy delays, particularly during periods of peak traffic flow. It was also a main route for tram services, primarily from Salford into Trafford Park, thus causing further delays for many when in use during busy periods. It was Grade II listed in 1987.

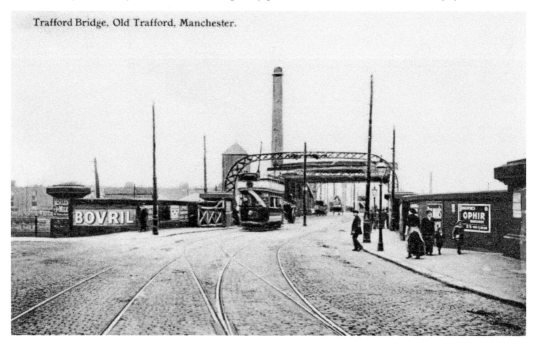
Trafford Bridge, Old Trafford, Manchester.

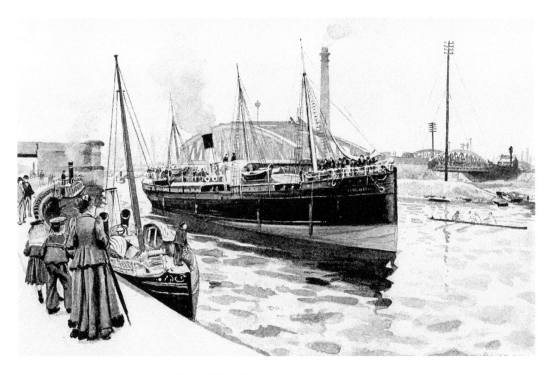

Trafford Road Swing Bridge, Old Trafford, *c*. 1894

The bridge was built across the Manchester Ship Canal between Manchester Docks and Pomona Docks around 1892. It was fabricated by John Butler & Co. and is the largest and widest of the ship canal's seven swing bridges, weighing 1,800 tonnes. In the 1990s, it was refurbished and fixed in place as part of a scheme to widen the road, creating a dual carriageway, with a new bridge built alongside. Adjacent to the bridge was the hydraulic tower, on the canal's north bank.

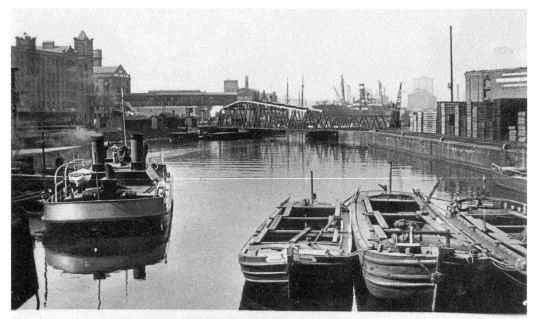

SHIP CANAL, OLD TRAFFORD.

The Manchester Ship Canal at Old Trafford, *c.* 1910
Just downstream from Trafford Road Swing Bridge was Trafford Railway Swing Bridge (above), which linked the old dockyards to the industrial estate of Trafford Park. The old railway swing bridge was dismantled and now has a new use as a pedestrian footbridge across what was once No. 9 Dock. Today, it has been refurbished and renamed Detroit Footbridge. The old foundations can still be seen opposite Sam Platt's public house. Imperial War Museum North and Salford Quays are also visible.

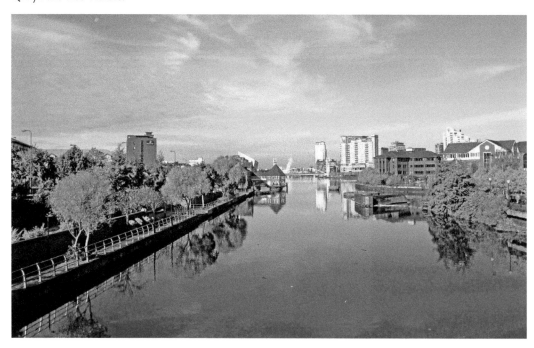

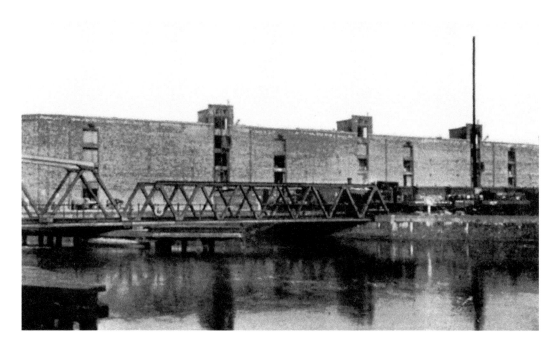

Railway Swing Bridge (Detroit Footbridge), from Trafford Wharf, Showing No. 6 Dock Warehouse (South Quay), *c.* 1900

This was built around 1895, carrying a single-track railway, and was widened and replaced by a double-track railway in 1942, to remove this bottleneck. The first crossing of the new bridge was made on 5 April 1943. It was constructed of steel lattice girders and used hydraulic power to open and close. The bridge continued in use until 1981. In 1988, it was moved to No. 9 Dock, crossing the dock between Huron and Erie Basins (*see* inset). The structure was floated to its new location on a barge.

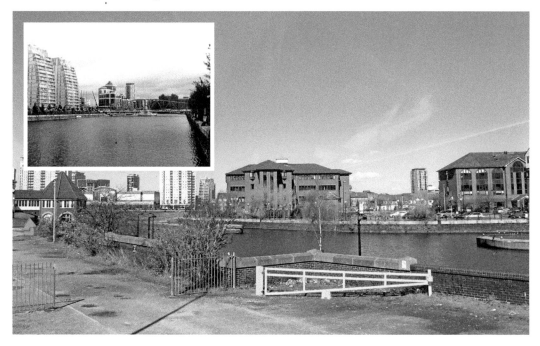

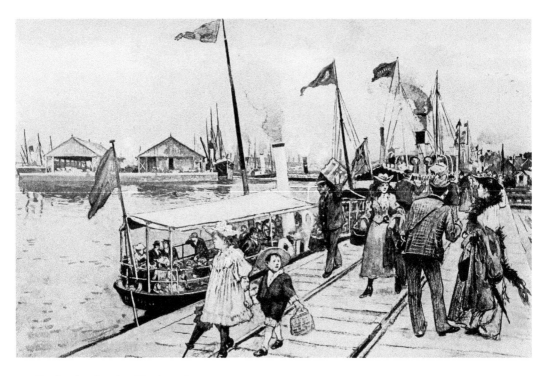

Trafford Wharf and Salford Docks, c. 1894

Trafford Wharf was located opposite dock numbers 9 (from 1905) to 6, shown in the background of the above image. The wharf was on the Trafford side of the docks. The main occupation here was connected to activities along an extensive timber wharf, which included a cattle-handling area and a graving dock (dry dock) nearer to Mode Wheel Locks. There was also a grain elevator along Trafford Wharf, opposite No. 9 Dock. Today, Imperial War Museum North and ITV's *Coronation Street* studios occupies the site.

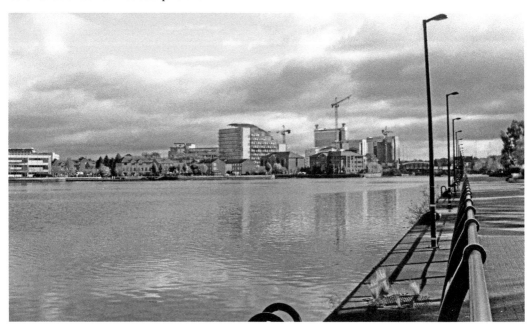

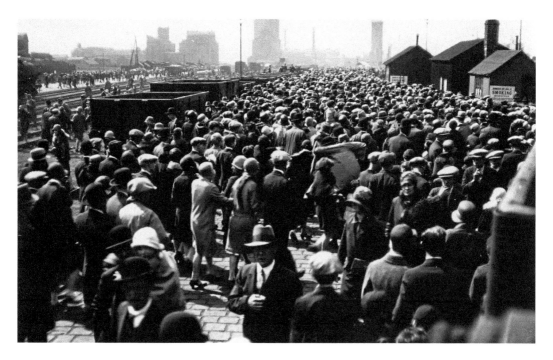

Trafford Wharf, Looking Towards Grain Elevator No. One (centre), *c.* 1920

The Grain Elevator opposite No. 9 Dock can be seen in the distance (centre), at the height of the daily rush hour. Today, at this location on the Trafford Wharf side of the ship canal is the Imperial War Museum North. The photograph of this section of the wharf shows the extensive railway tracks that covered the docks complex and the Trafford Park industrial estate, and the labour-intensive nature of available occupations in this era, as displayed by the crowded dockside.

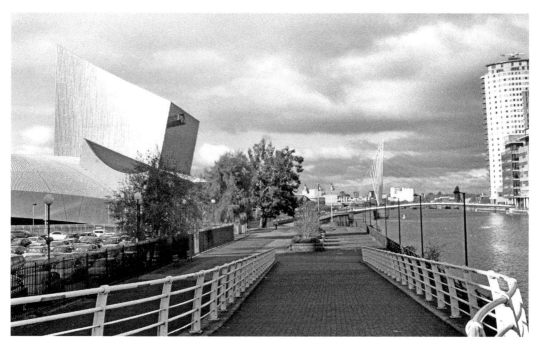

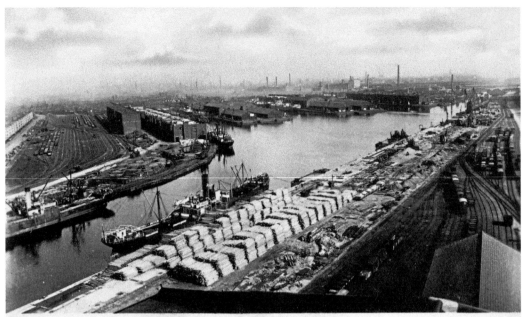

Nos.6.7.&8 Docks, Trafford Wharf, Manchester. P9.

Nos 6, 7 and 8 Docks, Salford & Trafford Wharf, c. 1910
During the 1970s, the docks went into rapid economic stagnation because of the increasing use of containerisation. The larger size of freight-carrying ships meant that they were no longer able to navigate the ship canal. There was also an increase in the amount of trade with Europe and the East. The combination of these two factors led to a steady decline in the use of Manchester Docks. In 1982 the docks closed and the area quickly became derelict.

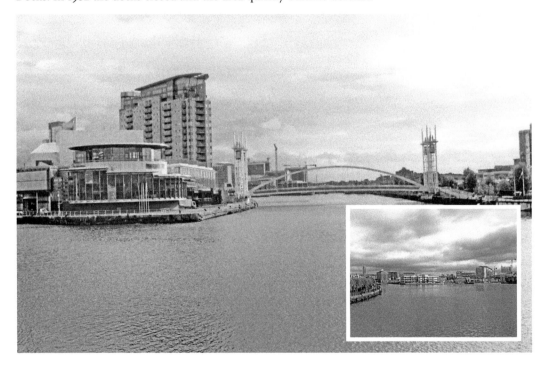

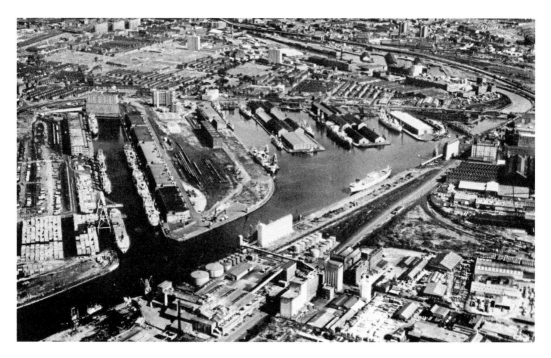

Nos 6, 7, 8 and 9 Docks, Salford, *c.* 1969
Note New Manchester Liners House under construction at the head of docks Nos 8 and 9, today
Erie Basin and Ontario Basin. It is now known as Furness House and stands on Furness Quay at
Salford Quays. The original Manchester Liners House was in St Ann's Square, Manchester, with
the new building designed to represent the bridge front of a vessel. There was a Customs and
Excise building attached at the rear of the premises, reflecting Manchester's role as a major port.

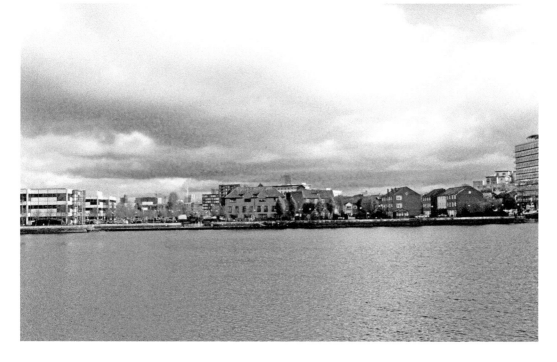

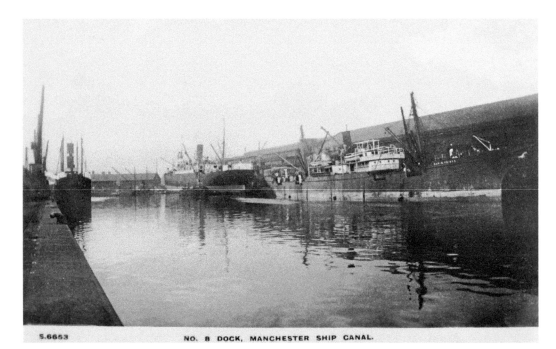

S.6653 NO. 8 DOCK, MANCHESTER SHIP CANAL.

No. 8 Dock and Carib Prince, Salford, c. 1918
The Manchester Docks covered areas of Salford, Stretford and Manchester, with nine docks in total. They were established as the Port of Manchester in 1894 and were closed in 1982. Coastal and ocean-going vessels delivered all types of cargo to the docks, with a limited number of passengers to and from Canada. There were two distinct areas, with Salford Docks to the west of Trafford Road Swing Bridge and Pomona Docks to the east, each originally with four docks.

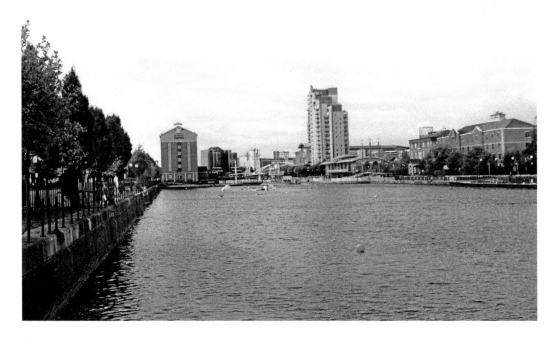

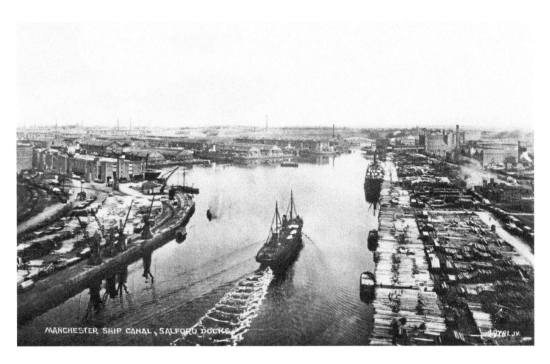

The Manchester Ship Canal, Salford Docks, *c.* 1900

The vessel pictured is heading in the direction of Pomona Docks, beyond the Trafford Road Swing Bridge, which is in the closed position, with the railway swing bridge in front of it in the open position. The length of Trafford Wharf can be seen quite clearly on the right, which was used extensively as a timber wharf at this time. To the left are numerous dock cranes, more timber, and dock Nos 8, 7 and 6. Today, the Millenium Footbridge crosses at this point.

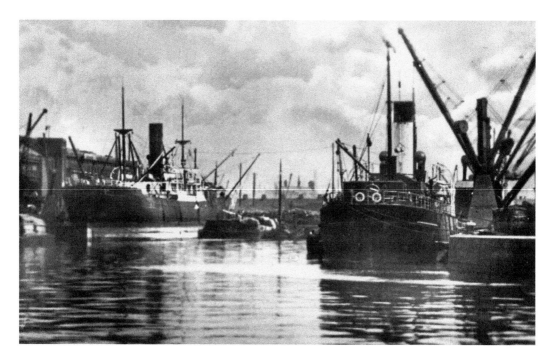

SS *Manchester Miller* (left) and *The Meganser* (right) at No. 9 Dock, Salford, 1919
Manchester Liners was founded in 1897, after the Manchester Ship Canal opened in 1894. It was a partner to Furness, Withy & Co., and sailed mainly to Canada importing and exporting cattle, although there was accommodation for a limited number of passengers. Galveston and New Orleans were also destinations for cotton production. In 1901, a service to Philadelphia was introduced and in 1906, to the River Plate, although both were short lived; later, in 1952, a service to the Great Lakes began.

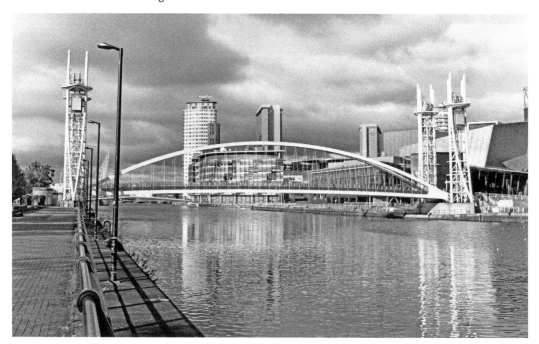

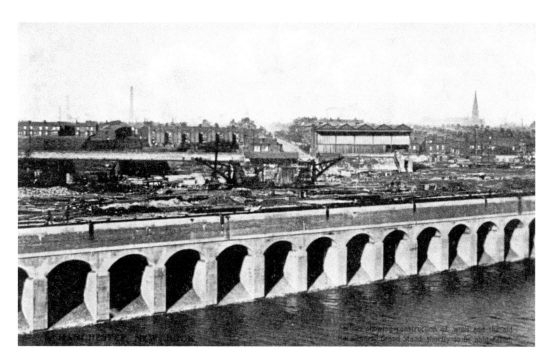

Manchester New Dock and the Old Racecourse Grandstand, Shortly Before Demolition, 1905
Horse racing continued at New Barns Racecourse for over thirty years, but in 1889 the course was served notice that the Manchester Ship Canal Co. were to compulsorily purchase their land in order to construct a new dock and warehouses. After lengthy legal proceedings, the company took possession of the land in 1902 and the New Barns Racecourse closed, with the new dock (No. 9) opening in 1905. It is now the site of much of the Media City complex.

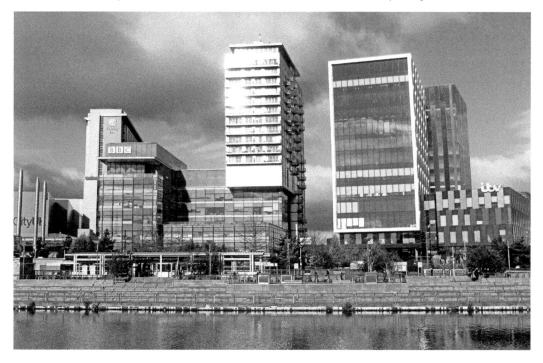

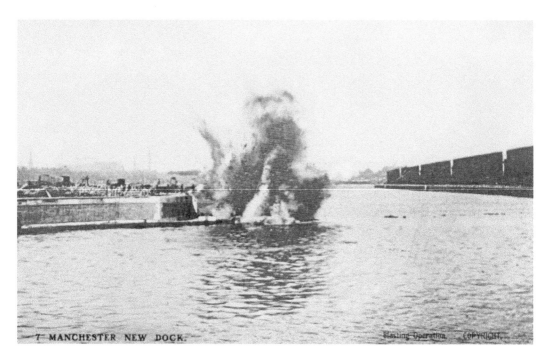

Blasting Operation at the Entrance to No. 9 Dock, 1905

The iron barrier separating the working canal from the new No. 9 Dock had been pre-prepared with boreholes so that when the new dock was full of water, the barrier could be blasted away, as shown. No. 9 Dock is seen from Grain Elevator No. 1, Trafford Wharf. The elevator had a wooden interior and brick skin, costing £84,000 to construct. It had a storage capacity of 40,000 tons and could unload grain from a hold at the rate of 350 tons per hour.

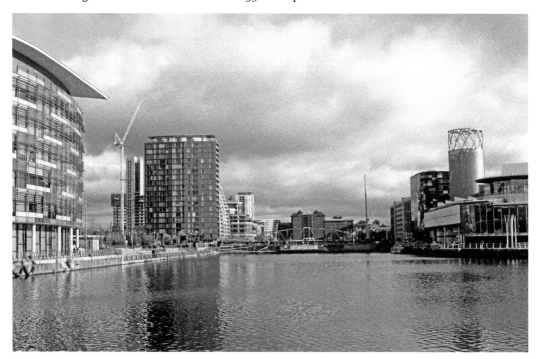

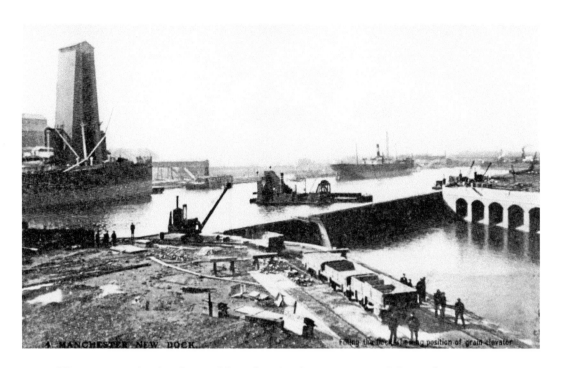

Filling No. 9 Dock, Showing Position of Grain Elevator No. 1 and the Dock Entrance, 1905
Grain Elevator No. 1 on Trafford Wharf dominated the Salford end of the Manchester Ship Canal. It was capable of holding 1.5 million bushels of grain in its 268 bins. The elevator was designed by John S. Metcalf of Chicago and was the largest of its kind in Europe, opening on 4 July 1898. It was destroyed by a German incendiary bomb in 1940. After months of smouldering and burning, because it was full of grain, the elevator was finally demolished.

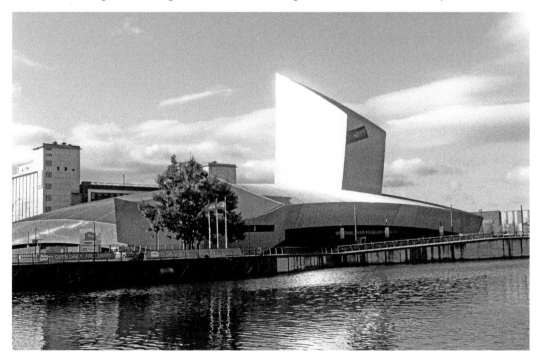

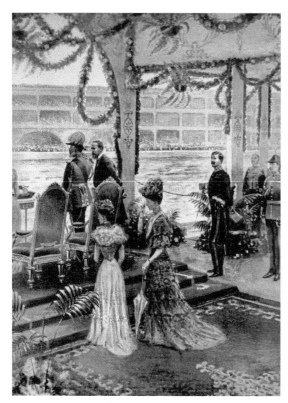

Edward VII at the Opening of No. 9 Dock, 13 July 1905

On the evening of the opening of No. 9 Dock by King Edward VII and Queen Alexandra, the councillors in Stretford organised a social evening for local people at the town hall in Stretford. The invitation read, 'The chairman (Mr Thomas Johnston, J. P.) and members of the council request the pleasure of the company of ... and Lady, at the Town Hall, Stretford, on Thursday, the 13 July 1905, to spend a Social Evening. Reception 8 to 8.30. Supper 8.45. Evening Dress. Carriages 12 to 2 o'clock. R.S.V.P.'

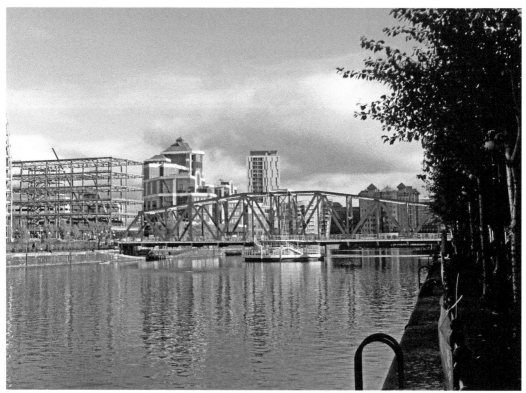

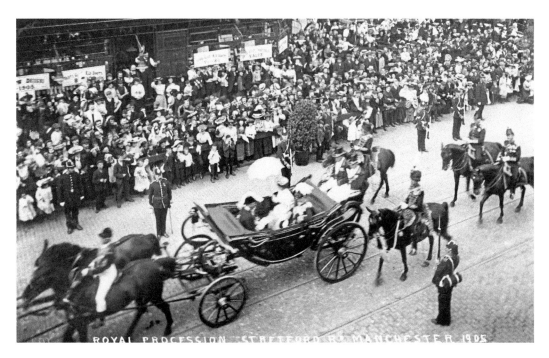

Royal Visit, Trafford Park Entrance, Opening of No. 9 Dock, 13 July 1905
The Trafford Park Estates Co. created their own tribute to the royal visit by constructing an arch made from the products manufactured by companies with premises in Trafford Park. The arch, celebrating the industry of Trafford Park, was located on Trafford Road, leading towards the docks. The motto 'Wake up England Trafford Park is Awake' refers to a speech given by the Prince of Wales in 1902. The colour scheme of the arch – purple, scarlet and gold – were the king's racing colours.

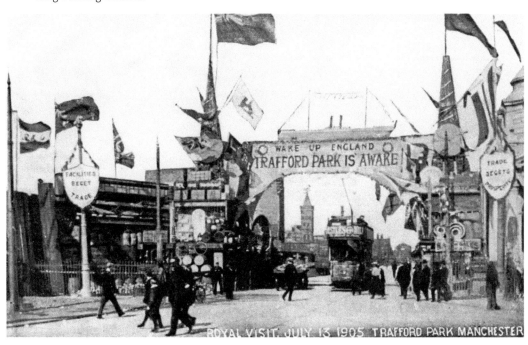

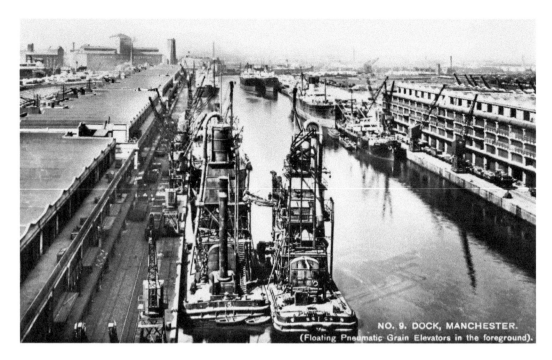

NO. 9. DOCK, MANCHESTER.
(Floating Pneumatic Grain Elevators in the foreground).

No. 9 Dock and Floating Grain Elevators, 1929
In the early 1980s, when the Manchester Docks became derelict, the former No. 9 Dock became a focus for regeneration and is now home to the iconic Lowry Centre, Media City and residential developments. Salford City Council purchased the docks in 1984, using a derelict land grant, and the Salford Quays development plan was proposed and introduced in May 1985. It led to the reclamation and development of the docks for retail, commercial, residential and leisure activities and the area's rejuvenation.

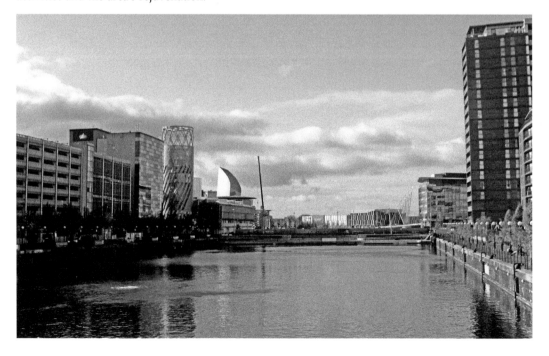

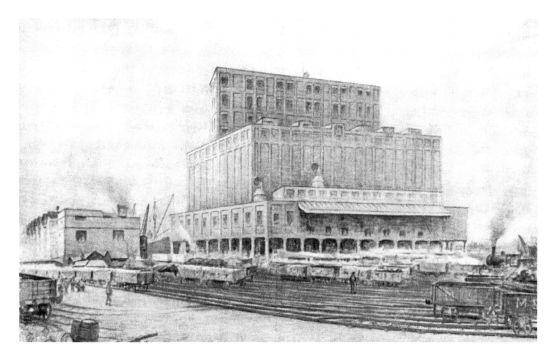

Grain Elevator No. 2, No. 9 Dock, 1915

Grain Elevator No. 2 was constructed in 1915 by Henry Simon Ltd. It was 51 metres (168 feet) high, overlooking No. 9 Dock. Demolished in 1983, it took nearly three months to clear away. The Anchorage now stands here. It held 40,000 tons of grain and received up to 900 tons an hour. Electrically driven conveyor bands ran under the quays of the adjoining dock. By their means six vessels – some 804 metres (half a mile) away – could discharge grain in bulk into the elevator at the same time.

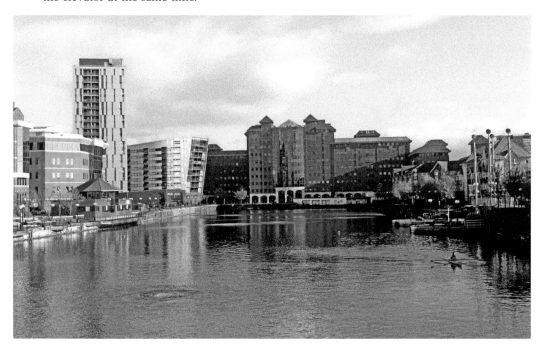

Manchester Ship Canal.

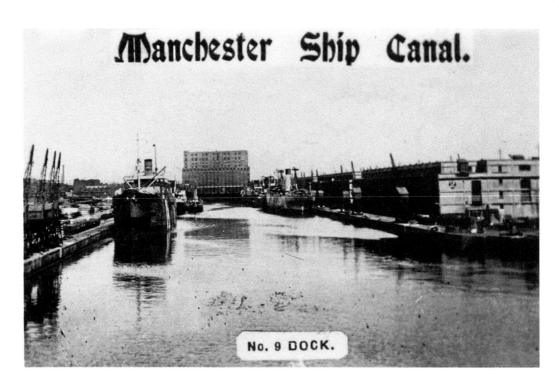

No. 9 DOCK.

Manchester Liners, Berthed at No. 9 Dock, c. 1920
Manchester Liners was a pioneer of the use of ocean-going vessels along the Manchester Ship Canal. As well as regular sailings to Canada and the Great Lakes, there were also services to the Mediterranean. All vessels were registered in the Port of Manchester, with No. 9 Dock their berthing quay. Later, the company's headquarters were built here. In 1980, the company was taken over by C. Y. Tung of Hong Kong, with Manchester Liners ceasing to trade in 1988.

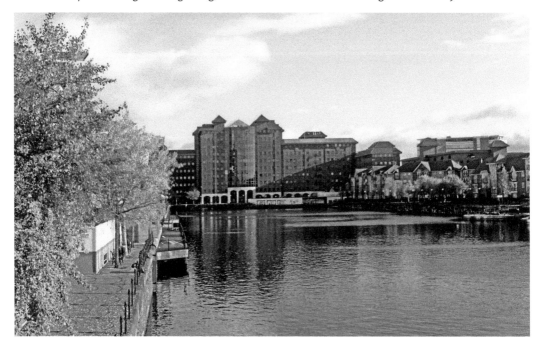

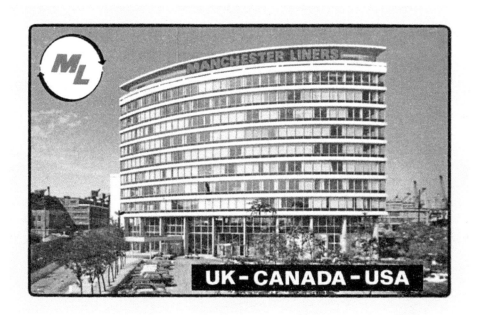

Manchester Liners House, Furness Quay, *c.* 1970

The new Manchester Liners House was built in 1969 and was opened on 12 December of that year by Mr Charles Ritchie C. C., High Commissioner for Canada, who unveiled a plaque at the totem pole. At the time this was located outside the entrance to Manchester Liners House and stood in honour of the trade and friendship established between Canada and Manchester Liners. Chairman Mr Robert B. Stoker requested the totem that was carved by the Kwakiutl tribe from British Columbia.

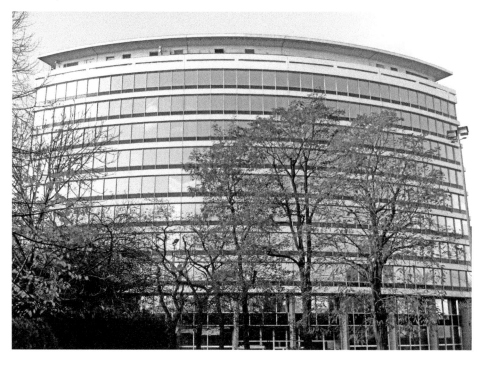

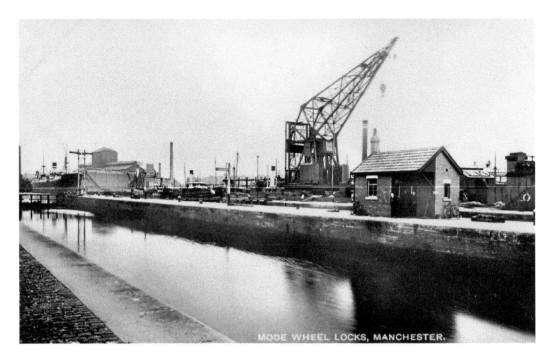

MODE WHEEL LOCKS, MANCHESTER.

Mode Wheel Locks, *c.* 1900

Mode Wheel Locks are the first locks on the ship canal after Salford Docks. The two locks located here raised ships 3.9 metres (13 feet) to the level of the Salford Basin, and to the final destination of Salford Docks, Trafford Wharf, or beyond Trafford Road Swing Bridge to Pomona Docks. It was an 18.4 metres (60 feet) total climb from Eastham. Water enters the locks via sluices, positioned in tunnels, which are located in the lock's walls. The tower was part of the pumping system controlling water flow.

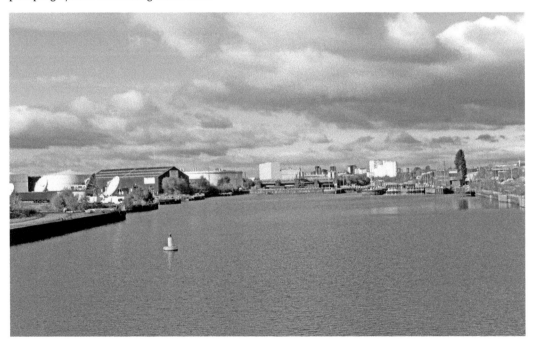

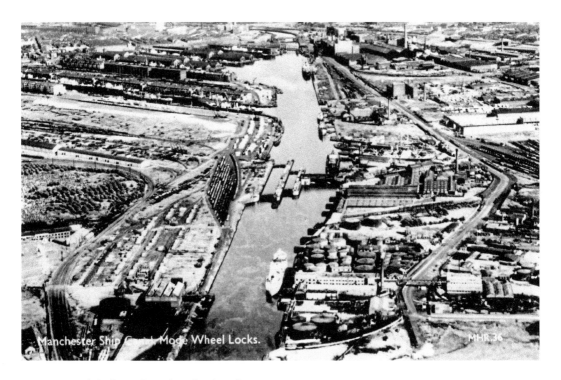

An Aerial View of Mode Wheel Locks, *c.* 1950

Before the ship canal was built, this waterway was known as the Mersey and Irwell Navigation. There was a corn mill, known as Maud Wheel Mill, and a much smaller lock here, with a weir located next to them. The mill was water powered, with its wheel being referred to as 'Maud's Wheel', corrupted to the title Mode Wheel over time and later adopted as the area's name. All were demolished in order to construct the canal and new, much larger, locks.

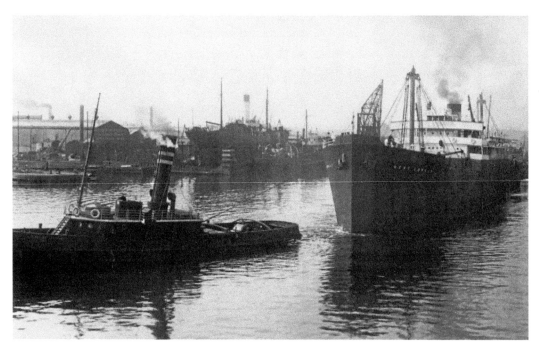

Lord Stalbridge Leads SS *West Cobalt* Away From Mode Wheel Locks, *c.* 1922
The walls of Mode Wheel Locks were built of concrete, which is lined with brick above the waterline. Cornish granite was used to finish the structure and it is clear that the locks have stood the test of time well. On 12 August 1981, areas around the docks in Salford and the Trafford Park Industrial Estate, in Trafford, became the first of a number of enterprise zones, resulting in large-scale redevelopment, which can be seen on both sides of the canal basin today.

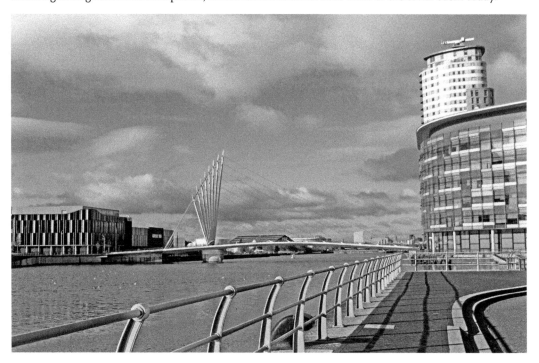

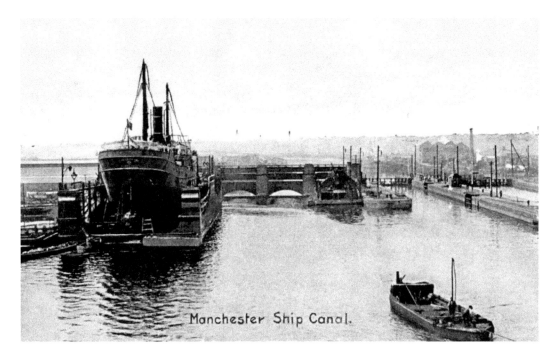

Mode Wheel Locks and Dry Dock, c. 1905
Mode Wheel Locks is the first set of locks to be navigated by ships making their way out of the docks. Shown, around 1905, is a vessel above the waterline, secured in the dry dock and next to the sluice gates of Mode Wheel's weir, with the locks complex on the right. Today, the locks complex is flanked by the Manchester Fuel Depot on the left and Broadway on the right. Weaste Wharf and an oil wharf are beyond the locks.

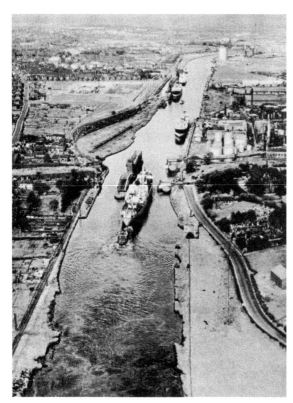

Manchester Oil Refinery and
St Catherine's Church (right), Eccles
and Patricroft (left), c. 1940
On the outskirts of Manchester there
are many wharves and landing stages.
At the top of the image, before the
canal bends to the right at Little
Bolton, is the Cerestar Wharf, where
raw materials like maize are unloaded
and other edible products are loaded.
Close by is Centenary Vertical Lift
Bridge, opened 1995 (below), with a
span of 43 metres (141 feet). It was the
first movable bridge to be built on the
canal since 1895. Completed in 1994, it
was opened by the Queen.

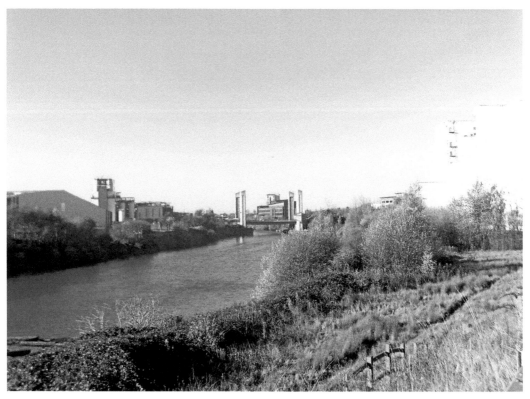

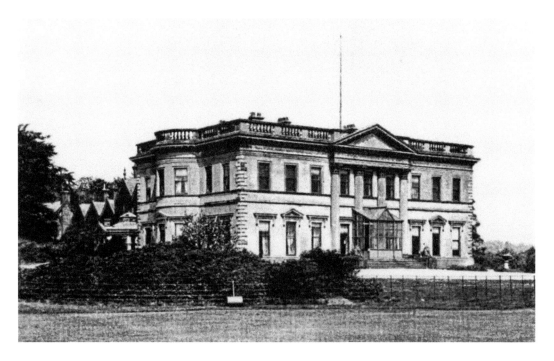

Trafford Park Hall and Estate, East of Barton, 1896 |
Once a rural estate, deer roamed freely around the grounds of Trafford Park and the hall was surrounded by an ornamental garden, with a glass conservatory and kitchen garden. The rear part of the hall was ivy-clad and dated from Elizabethan times. Inside, there were eight main reception rooms and a glass fernery. The main entrance hall was nearly 1,200 square feet in area. There were over forty bedrooms on the first floor, which also housed the de Trafford's private Catholic chapel.

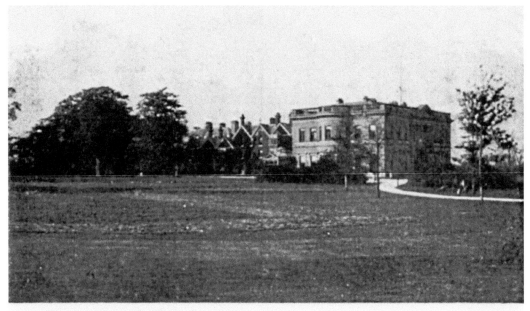

Trafford Park & Hall, Manchester.

Trafford Park Hall and Estate, East of Barton, 1896 II

The Barton entrance lodges to Trafford Park Hall and Estate were originally sited on the banks of the Bridgewater Canal and were moved to Dumplington Lane, now Redclyffe Road, in the nineteenth century. They were demolished around 1920, when Barton Power Station was built. In 1896 the de Trafford family sold Trafford Park Hall and Estate to Ernest Terah Hooley, who then formed the Trafford Park Estates Co. The hall was demolished around 1946, after it was damaged by bombing in 1940.

Walter Kershaw's Mural, Liverpool Warehousing Co. Ltd, Old Trafford, 2013 and March 2014
Victoria Warehouse, built between 1906 and 1910, once housed the Liverpool Warehousing Co. Ltd (1925). It has been the location of two huge murals by artist Walter Kershaw, depicting the industries of Trafford Park, including the canal. The first, dating from October 1982, was commissioned by the Trafford Park Planning Department and unveiled by ex-Manchester United footballer Denis Law. This was replaced on 1 November 1993, although it has now been removed (March 2014). Recent plans have seen the site converted into a hotel.

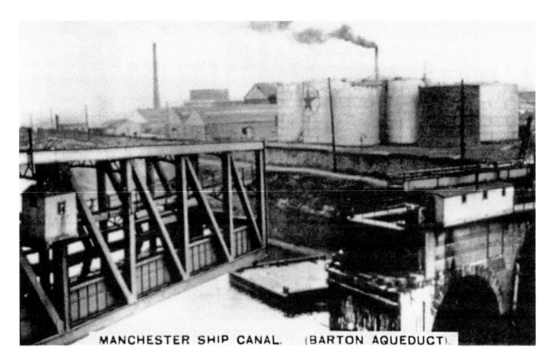

MANCHESTER SHIP CANAL. (BARTON AQUEDUCT).

Barton Oil Terminal and Swing Aqueduct, *c.* 1940

Manchester Oil Refinery, at Barton, was founded in 1936. Their petroleum refinery manufactured lubricating and transformer oils and began production in 1938. In 1941, the refinery was briefly shut down due to restrictions imposed by the government but reopened when the advantage of refining products locally was realised. By 1960, the company was acquired by Lobitos Oilfields Ltd and by 1963 was owned by the Burmah Oil Co., who closed it in 1972, but continued production at Ellesmere Port, opened 1934.

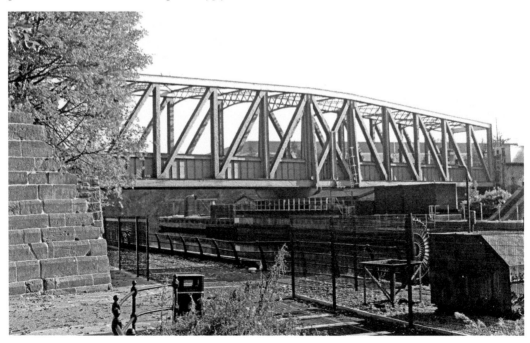

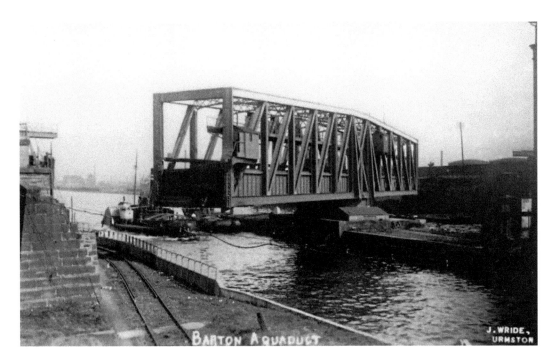

Barton Swing Aqueduct, *c*, 1900

The crossing was originally undertaken by ferryboat, from around 1586, with the first bridge constructed in 1681 and repairs undertaken in 1746. Before the new aqueduct was built, a stone structure, demolished around 1891, stood at the site. Shipping was limited by the size of the bridge's arches and only barges known as 'Mersey Flats' were able to negotiate the sometimes treacherous channels. Originally, Chapel Place and later Barton Oil Terminal were developed on the Trafford side of the canal, next to the new aqueduct.

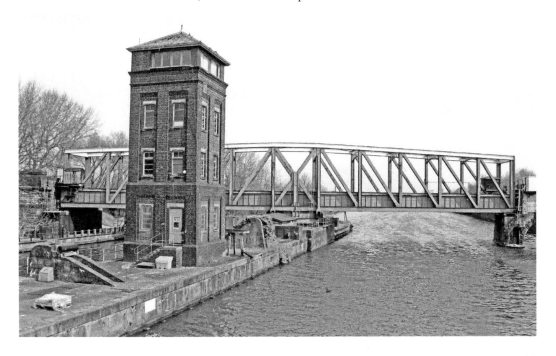

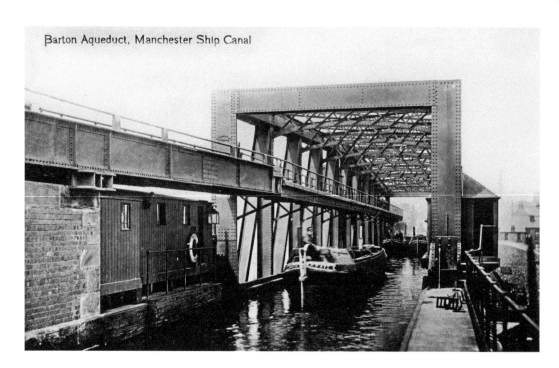

Barton Aqueduct, Manchester Ship Canal

Barton Swing Aqueduct, 1914 II

The Barton Swing Aqueduct is 71.6 metres (235 feet) long and weighs 1,450 tons. The bridge swings on a central axis to allow the passage of ships. The aqueduct takes the form of a boxed lattice girder, containing an upper section, the channel remaining full of water when turning. James Brindley (1716–72) designed the Bridgewater Canal, his stone aqueduct being built around 1761 and replaced around 1891. Some remains of this aqueduct are preserved on the Eccles side of the Manchester Ship Canal and are marked by a plaque.

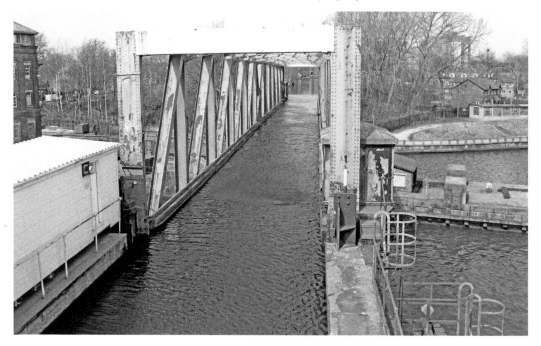

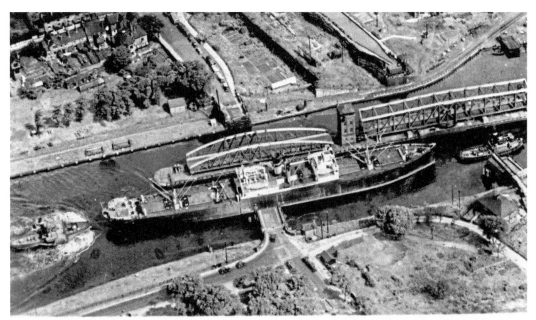

BARTON SWING AQUEDUCT AND ROAD BRIDGE ON MANCHESTER SHIP CANAL

Barton Swing Aqueduct and Road Bridge, Aerial View, c. 1950
The tug on the right of the image is just passing the aqueduct at Barton Oil Terminal. The size of the vessel is apparent as it passes the Barton Swing Bridge and Aqueduct. The course of the Bridgewater Canal can be seen top right, with the remnants of Brindley's stone aqueduct next to it. This vessel has just passed St Catherine's parish church and All Saints. A queue of traffic has accumulated on the Eccles/Patricroft side of the canal and is now 'bridged'.

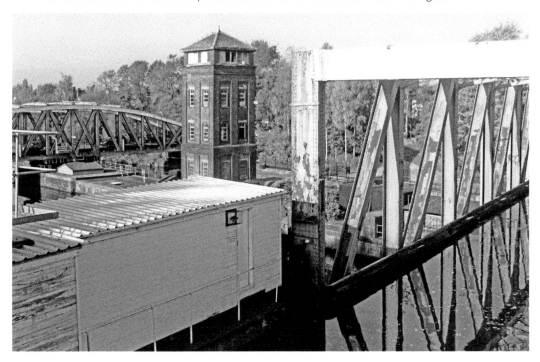

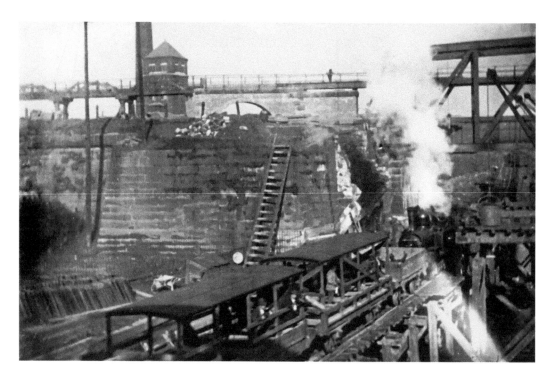

Barton Swing Aqueduct, November 1893

In 1893, Barton Aqueduct is in place, with the remains of Brindley's stone aqueduct in the centre of the picture. The first and only swing aqueduct in the world, barges began crossing on 21 August 1893, the aqueduct opening for commercial traffic on 1 January 1894. Construction work began in 1890, when a school on the south bank was demolished. The River Irwell's course was diverted, so a central island could be built on dry land. The aqueduct retained around 800 tonnes of water when turning.

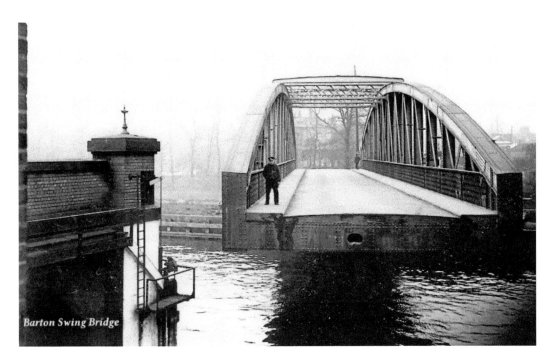

Barton Swing Bridge, c. 1900 l

Previously, there had been a bridge here for over 200 years. During the twentieth century it became an important access route for Trafford Park and for traffic bypassing Manchester and Salford city centres. It became a notorious bottleneck because of this and for swing-bridge delays. The Barton High Level Bridge alleviated the problem for many years and it is hoped the new A57 lift bridge will further reduce congestion, caused by the development of the Trafford Centre in recent years.

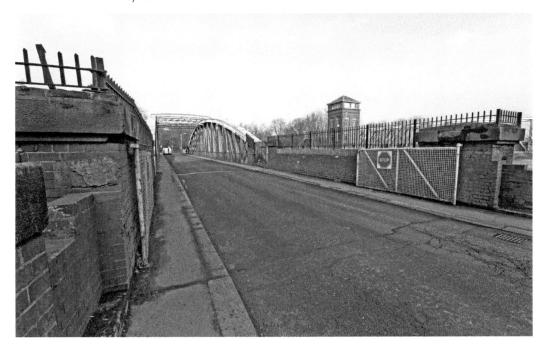

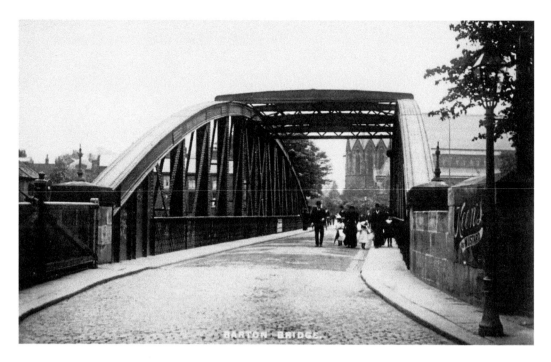

Barton Swing Bridge, c. 1900 II

It was constructed around 1893, with the whole complex of bridge, aqueduct and control tower Grade II listed in 1987. The engineer was Sir Edward Leader Williams (1828–1910), with Andrew Handyside & Co., providing the materials. It weighs 800 tons, is 59.4 metres (195 feet) long and 7.62 metres (25 feet) wide. It has a sixty-four-roller hydraulic system, enabling it to revolve on a central axis, allowing the passage of ships. These often expand in heat, causing the structure to lock and the travelling public to be 'bridged'.

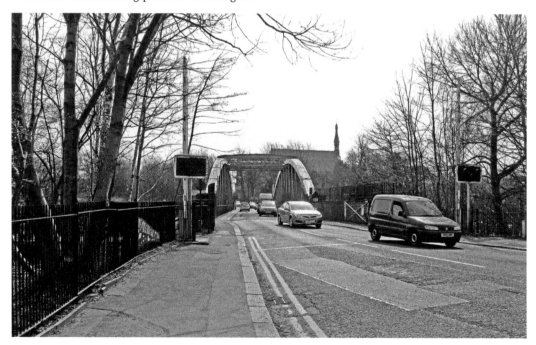

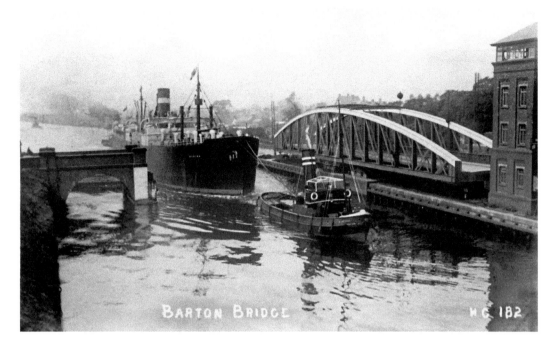

Barton Swing Bridge, *c.* 1900 III

The bridge is controlled from an old brick-built valve house on the man-made central island. The tower is four storeys high and the island provides the foundations for both bridges' pivot points, with a rack and pinion system connecting the road bridge to this mechanism. It is the only swing road bridge on the canal, rotating from the centre instead of from one end. In recent years both the Barton High Level Bridge and the Centenary Bridge have helped alleviate traffic congestion.

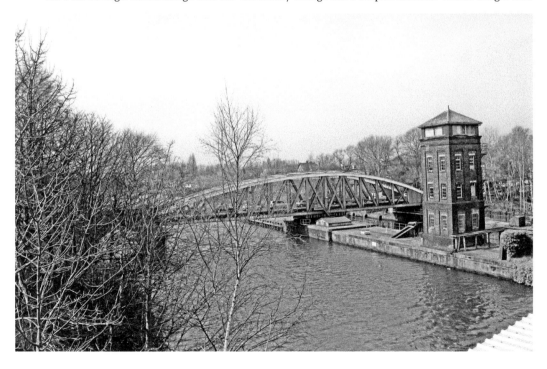

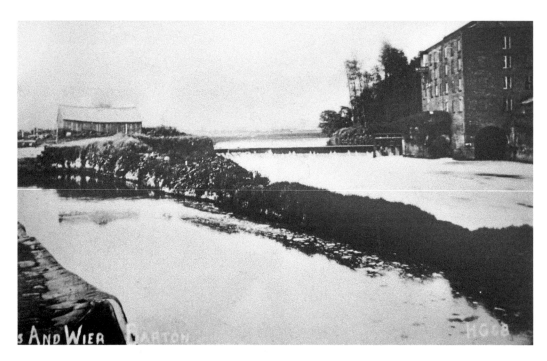

Barton Before the Manchester Ship Canal, Mills and a Weir, c. 1880
The Rivers Mersey and Irwell were made fully navigable from Warrington to Manchester by the Mersey and Irwell Navigation Co. Barges with a maximum length of approximately 20.1 metres (66 feet) and a maximum width of approximately 4.8 metres (16 feet) were using this section of the river by 1734. Known as 'Mersey Flats', these barges were specially constructed to negotiate the treacherous riverbeds and fast-flowing currents of the Mersey and Irwell. Navigation was improved by short canal sections and the construction of weirs.

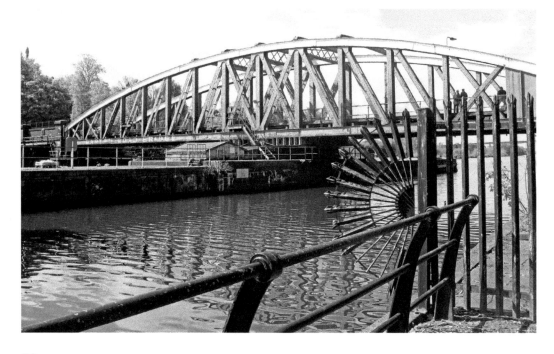

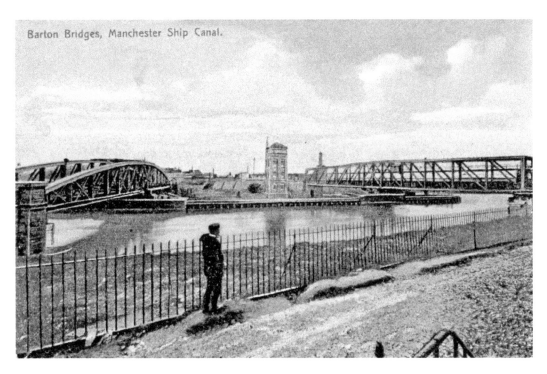

Barton Bridges, Manchester Ship Canal.

Barton Swing Bridge and Aqueduct, with a View of Eccles and Patricroft, 1909
The Barton Swing Bridge and Aqueduct are controlled by an operator located in the nearby control tower, when the bridges need to be in the open position. The tower was staffed on a twenty-four-hour a day basis in the past, reflecting the canal's important economic role, but today it is only staffed when needed. In the late 1980s the aqueduct's towpath, cantilevered over the Bridgewater Canal, was removed, together with the approach ramp on the Patricroft side.

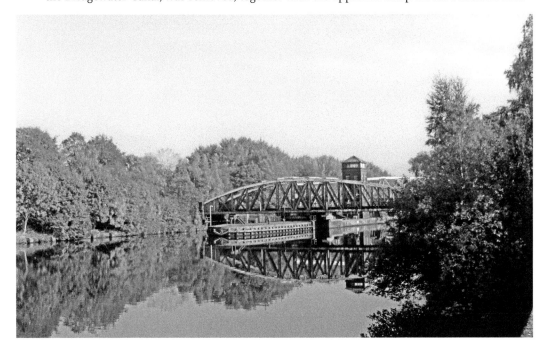

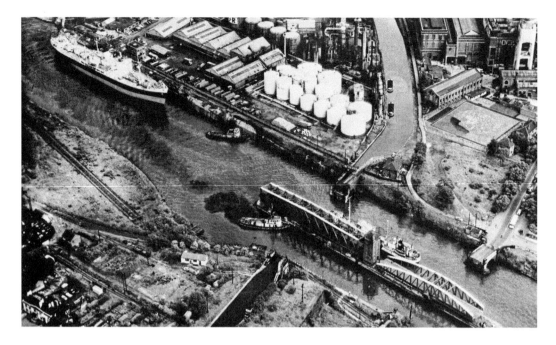

Aerial View of Barton Aqueduct, Road Swing Bridge, Manchester Oil Refinery, Barton Oil Terminal and Power Station, c. 1950

This is an aerial view of Barton's swing aqueduct and road bridge, but this time from the Eccles-Patricroft side. Clearly visible in the centre are the oil storage tanks of the Manchester Oil Refinery and later Esso. There is a tanker berthed at the oil terminal, probably loading, bound for Eastham and the open sea. The chimney supports of the Barton Power Station can be seen (top right), demolished around 1979 and now a DIY superstore.

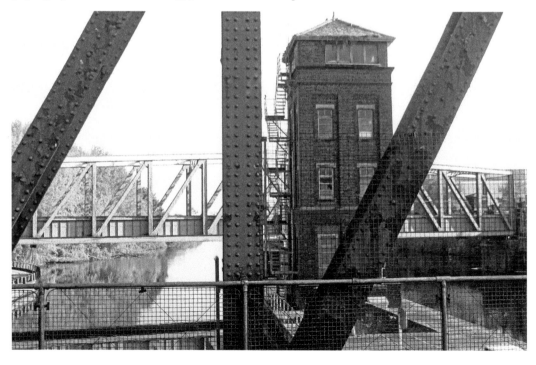

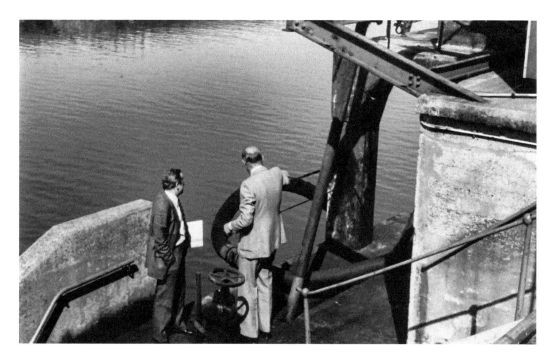

At Barton Dock Jetty, Late 1970s and Looking Towards Salford Quays, 2016
Shown are the managing director (right) and senior management of the Edgar Vaughan Co. of Trafford Park. The company manufactured lubricants used in industry and were based at Ashburton Road West, with the underground pipeline between their pump house and the Barton Dock Jetty, used to transfer oil products from tankers on the ship canal to oil storage tanks at their depot. The pipeline was discontinued around 1980 when a major fracture and oil leak made its application unviable.

Eccles and Patricroft from Barton Dock Jetty, Showing Pipelines, Late 1970s
A view from directly above the oil pipeline, in front of the small chalet, which Edgar Vaughan was using as an office base and shelter from any inclement weather conditions! Today, the opposite bank is tree-lined and the houses beyond are no longer visible from the Barton side. There has been a long history of oil production at this site, with Ashburton Road West at one time occupied by the Texas Oil Co. (Texaco) and then Gulf Oil, from at least the 1930s.

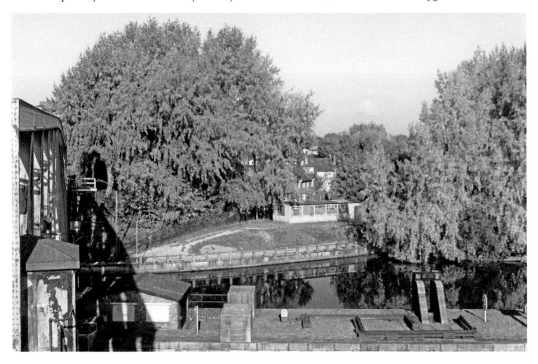

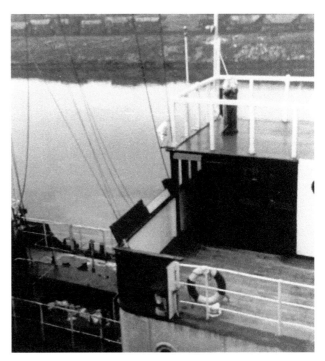

Unidentified Tanker Unloading at Barton Dock Jetty, Late 1970s
This is the bridge of an unidentified oil tanker, berthed at the Barton Oil Terminal while unloading its cargo of oil. These vessels were usually among some of the biggest on the ship canal but were inevitably limited by the size of the canal's locks and the depth of the canal. In the 1960s and '70s the development of supertankers, aided by the relatively cheap price of oil in the USA, led to the decline of the terminal by around 1980.

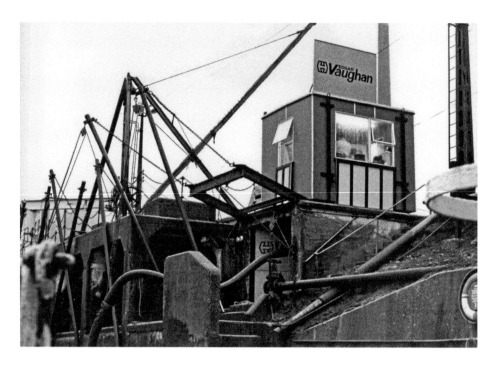

Underground Pipeline Entry Point at Barton Dock Jetty, Late 1970s
This image shows Barton Oil Terminal and the cabin used as an office base by Edgar
Vaughan, which doubled as sleeping accommodation at night. The process of transferring
oil from a tanker took many hours, and sometimes overnight supervision, meaning
working for a full twenty-four-hour period in many cases. The photograph looks from the
deck of a tanker, showing pipelines connected to the underground feed. The site is now
tree-covered and occupied by a warehouse.

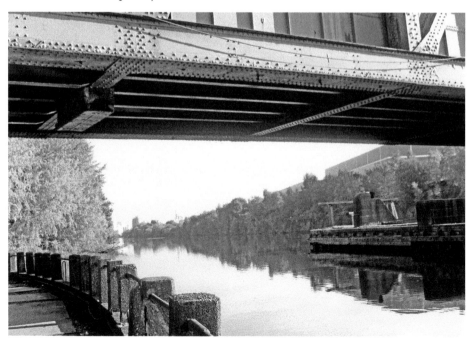

A View Looking Towards Barton High Level Bridge, 2015

Opened in 1960, it carried the Stretford and Eccles bypass over the canal and was later renamed the M62, the M63 and now the M60. Next to the high-level bridge, a new lift bridge is being constructed to carry the A57 over the canal. Its supporting pillars are visible on either side of the canal in 2016. On 16 May 2016 the bridge deck collapsed; fortunately, no one was injured. A construction accident on the high-level bridge, on Wednesday 30 December 1959, killed two and injured eight.

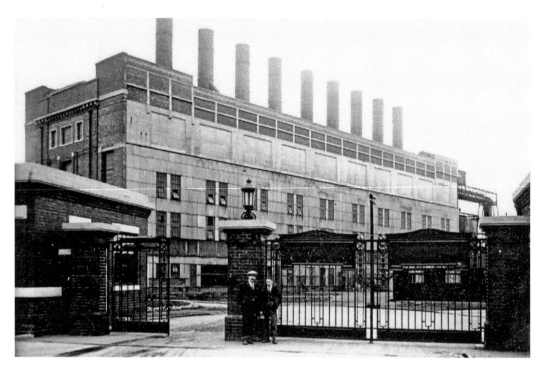

Barton Power Station, Redclyffe Road, 1920
From Barton Power Station, which was demolished around 1979, the canal heads towards Barton Locks, which lower vessels 4.5 metres (15 feet) towards Irlam Locks. Beyond the locks are the Davyhulme Sludge Berths (*see* inset), a part of the vast sewage and waterworks complex at Davyhulme. They are now disused and border the Millenium Nature Reserve. Close by is the Hulme's Bridge Ferry, a spring and summer canal crossing between Davyhulme and Irlam. The ferryman's cottage is close to the landing stage here.

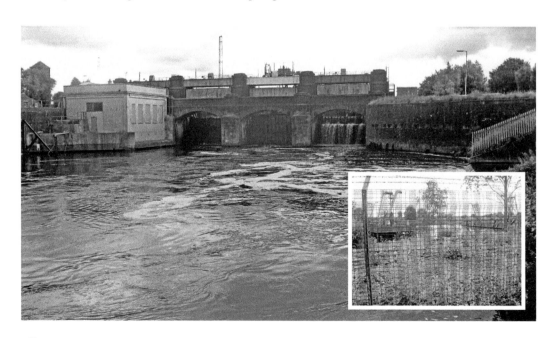

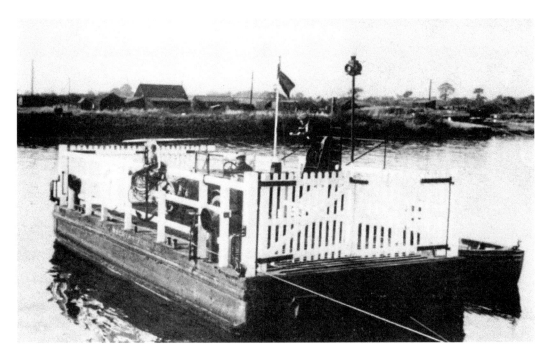

Irlam Ferry, c. 1930

The Irlam Ferry is being cranked towards Flixton. Later, the ferry was propelled with one oar at the stern and then in May 1968 the MSC Traverse replaced the single-oar boat. The ferry closed around 1975. It could carry up to six people, with a charge of 1d. On 29 March 1961, questions were raised in the Commons about the provision of a ferry service here. There were concerns motorised traffic could not cross and that people could not access their place of employment.

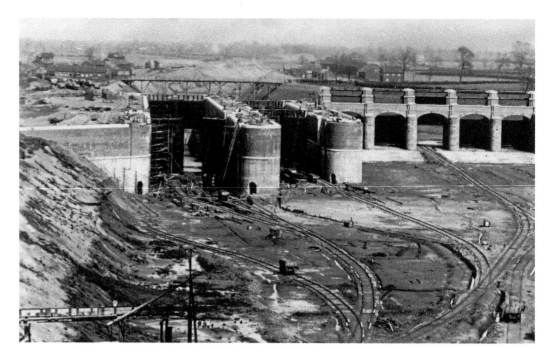

Irlam Locks, from Flixton, *c. 1890*

This photograph of Irlam Locks under construction illustrates the huge scale of the undertaking. Irlam were the third set of locks encountered by vessels on the ship canal, heading from Manchester. The locks are located on the left of the photograph, with the sluice gates on the right. Behind the photographer is the River Mersey Weir, where the river flows into the canal. The photographer is stood on the approach to Irlam Viaduct, which carried the Cheshire Lines Committee Railway from Warrington to Manchester.

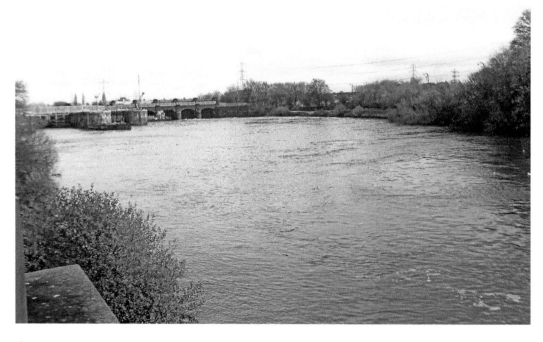

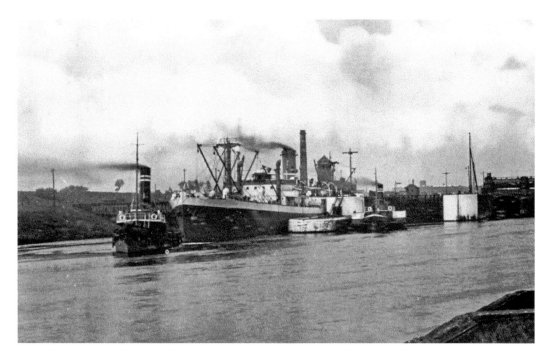

Irlam Locks and CWS Wharf, from Flixton, *c.* 1950

Excavations here included a temporary contractor's railway and Irlam Viaduct, which was finished in advance of the canal's opening in 1893. The Cheshire Lines Committee Railway crossing at Irlam meant that Irlam Locks had to be upstream of the rail crossing to maintain the required 22.8 metres (75 feet) clearance for ships. This height was determined by the clearance of the existing viaduct, built from 1863–68, over the River Mersey and canal at Runcorn and was required so that ocean-going ships could reach Manchester.

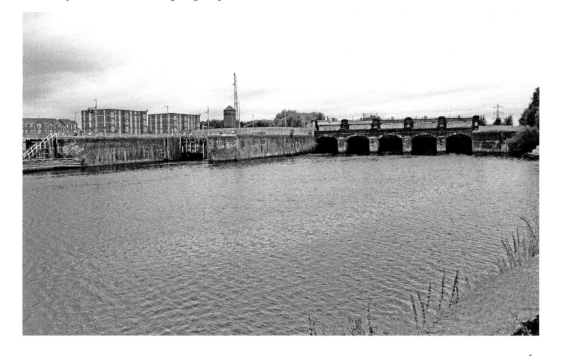

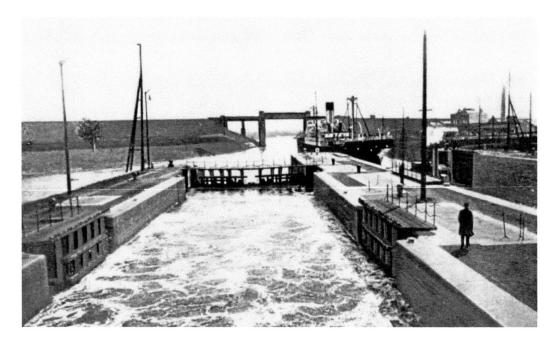

Irlam Locks, Carrington Power Station, Irlam High Level Railway Viaduct and Former CWS Wharf and Factory Site, Irlam, *c.* 1894

Beyond the railway viaduct, on the left, is the Mersey Weir, where the river runs directly into the canal, before Partington. Embankments of a mile on each side were constructed for the required approach gradient on the Liverpool–Manchester high-level viaduct. It was meant to be identical to the Cadishead Viaduct (*see* inset). However, subsidence meant its brick arches were replaced with horizontal steel girders, completed May 1895. Irlam Locks lower vessels 4.8 metres (16 feet) towards Warrington, with the CWS Factory (on the right) demolished.

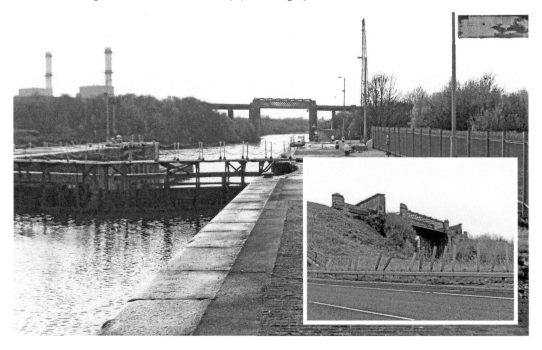

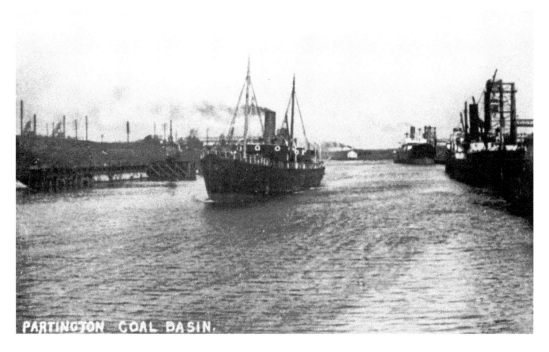

Partington Coaling Basin, 1905

There were bunkering or coaling points along the length of the canal, so that ocean-going vessels could refuel before undertaking or returning from a long journey. The Coaling Basin is now known as Partington Petroleum Basin. On 24 April 1970, the Cadishead-Partington (Bob's) Ferry Disaster occurred. Five died when petrol leaked into the canal while loading a tanker berthed here, causing an explosion. A sixth victim later died in hospital. Understandably, the ferry's use declined rapidly after this incident.

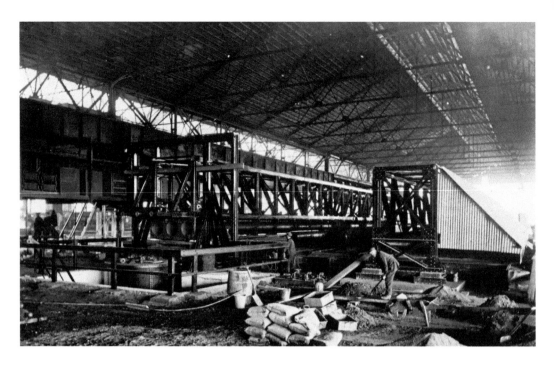

Irlam Steelworks Sorbitic Plant Rolling Mills, Cadishead Way, Irlam, 25 August 1930
A modern industrial estate now occupies the site of the former steelworks, with the Partington Petroleum Basin built where the wharf at Irlam handled coal and ore used by the Lancashire Steel Corporation. The Cadishead railway viaduct and line to Glazebrook crossed the canal at this point (*see* inset), although the viaduct is now disused and in poor condition. When the steelworks were in operation, there were many lines and sidings here. Cadishead Way Stage Two and Northbank Bridge (*see* inset) opened on 16 September 2005.

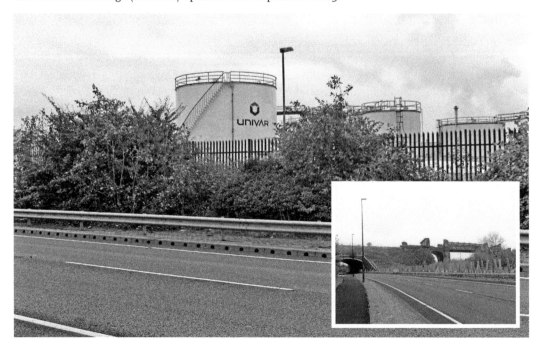

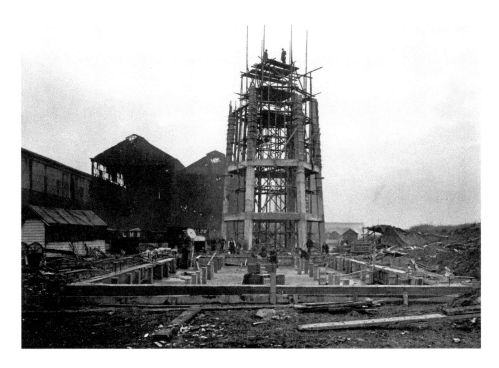

Irlam Steelworks Water Scheme – Cooling Tower and Pond, Cadishead Way, 7 December 1930

Irlam Steelworks opened 1910 and employed many local people until its closure in 1979. Northbank Industrial Estate now occupies the site. After the canal opened in 1894, many companies sought the sea and rail access that it now provided. Steel, soap (in the form of Irlam CWS Soapworks near Irlam Locks) petrochemicals and food production brought economic growth to the area. Below is CWS Soap, Candle & Starch Works Locomotive No. 8, Peckett & Sons (Bristol) 0-4-0 Fireless type, built February 1955. At Northbank, courtesy the Rotary Club of Irlam.

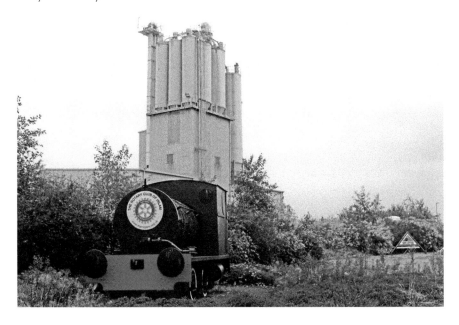

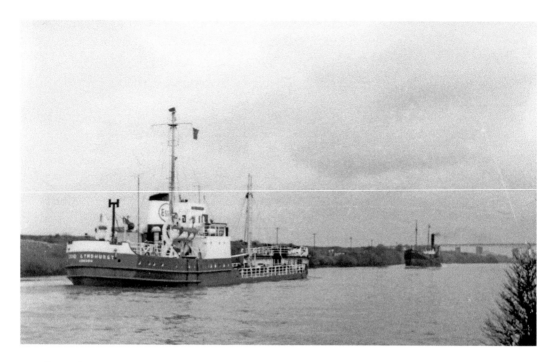

Lyndhurst (Esso) Passing Peakdale (Manchester Ship Canal), near Thelwall Ferry, 2 April 1967
The Thelwall Viaduct carries the M6 motorway across the canal. Construction of the first bridge started in 1959 and was completed in July 1963, with the second bridge opened in 1995. The Thelwall 'Penny Ferry' (*see* inset) is at the end of Ferry Lane and has been here since 1894. The canal cut through a farm and footpath at this point, so a ferry and not a bridge was opted for. Initially it ferried cattle, horses and carts, as well as people, on a pontoon.

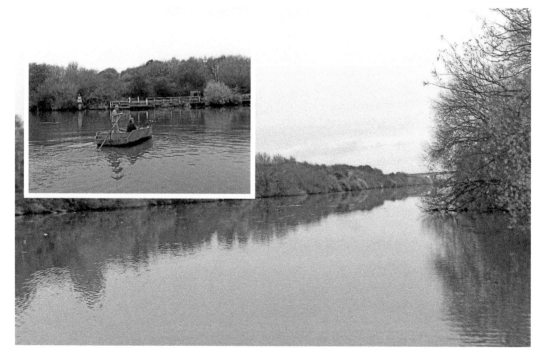

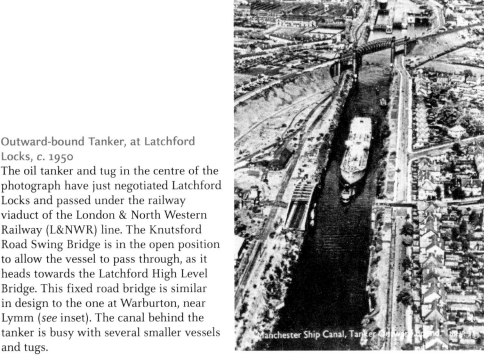

Outward-bound Tanker, at Latchford Locks, *c.* 1950
The oil tanker and tug in the centre of the photograph have just negotiated Latchford Locks and passed under the railway viaduct of the London & North Western Railway (L&NWR) line. The Knutsford Road Swing Bridge is in the open position to allow the vessel to pass through, as it heads towards the Latchford High Level Bridge. This fixed road bridge is similar in design to the one at Warburton, near Lymm (*see* inset). The canal behind the tanker is busy with several smaller vessels and tugs.

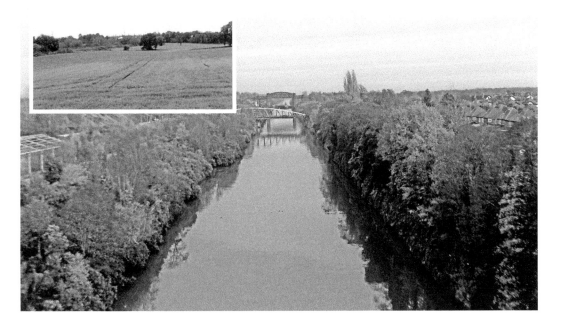

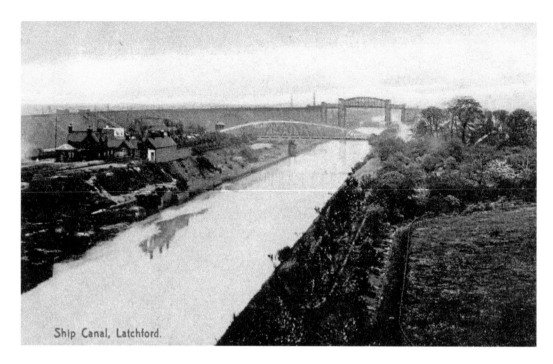

Ship Canal, Latchford.

Latchford Bridges and Locks, Warrington, c. 1905 I
Latchford lies to the south of the River Mersey and Warrington town centre. Here, there was an ancient ford where the river could be crossed before the first bridge was built and the township developed. When the Manchester Ship Canal was opened in 1894, it divided Latchford and gave the area several bridges across the canal (*see* inset). Latchford Locks were constructed to lower vessels 5 metres (16 feet 6 inches), and on towards Runcorn. The locks are still a visible landmark today, from Thelwall New Road.

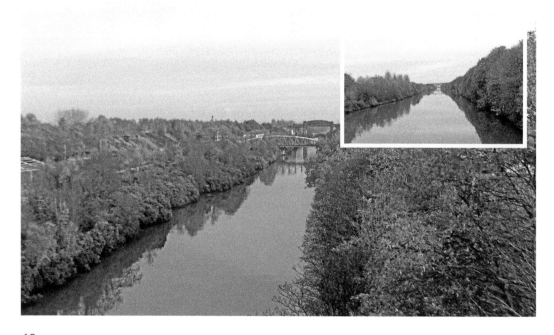

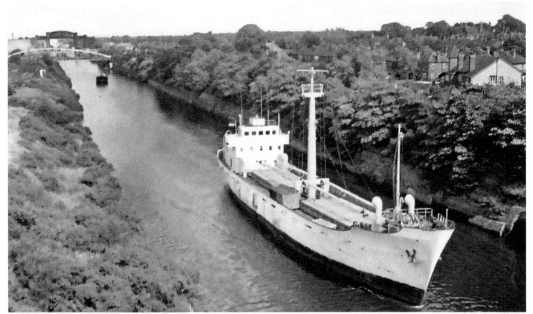

Manchester Ship Canal W.2912

Latchford Bridges and Locks, Warrington, c. 1970 II
Three swing bridges cross the canal at Warrington: the A50, Knutsford Road; the A49, London Road; and the A5060, Chester Road. The Stockport–Warrington line over Latchford Viaduct was operated by the L&NWR. The first passenger train climbed the 1:135 gradient and crossed the viaduct at 7.30 a.m. on Sunday 9 July 1893, and was discontinued in 1962, with freight discontinued in July 1985. Latchford Viaduct, Knutsford Road Swing Bridge and Latchford High Level Bridge were the last section to be completed on this stretch.

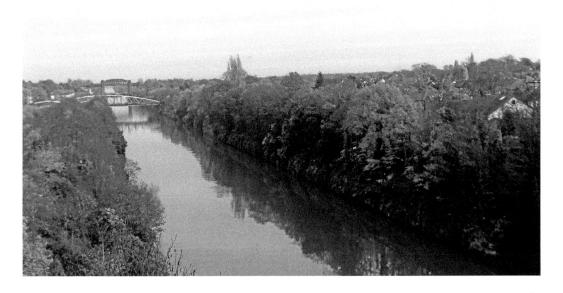

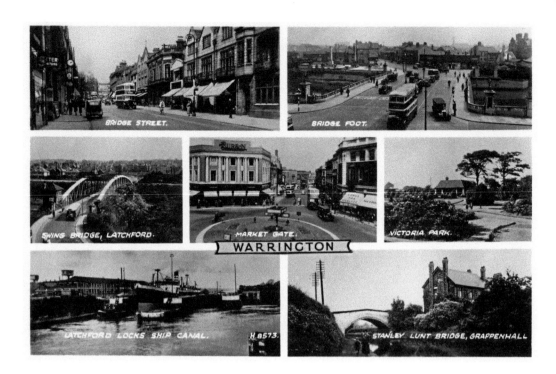

Latchford Locks, Warrington (bottom left), *c.* 1950

The fourth set of locks encountered by vessels bound for Eastham, which was 33.7 kilometres (21 miles) away. They consisted of a larger lock for ocean-going vessels and a smaller lock to its south for coasters, tugs and barges. Intermediate gates saved water. There was a ship mooring area on the south bank, so two larger vessels could pass. The viaduct opened on 9 July 1893 to carry the L&NWR's Stockport–Warrington line. Passenger services ended 1962 and freight July 1985, when the line officially closed.

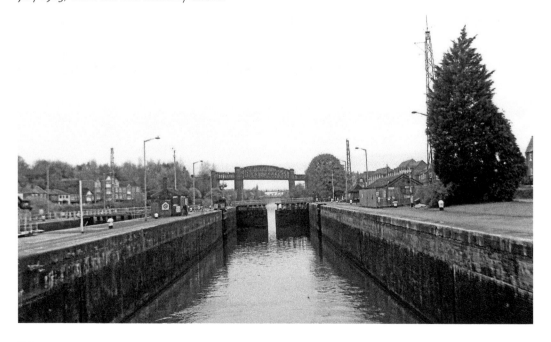

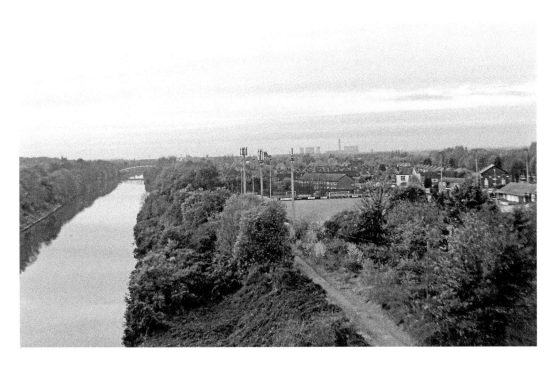

Fiddler's Ferry Power Station from Latchford High Level Road Bridge, Warrington and from Old Quay, Runcorn, 2016

A coal-fired power station opened in 1971 between Widnes and Warrington. Fiddler's Ferry was located here for its water supply and proximity to the Lancashire and Yorkshire coalfields. Its eight 114-metre- (374 feet) high cooling towers and 200-metre- (660 feet) high chimney make it a prominent landmark. It can be seen from as far away as the Peak District and Pennines. The name reputedly comes from the original landowner, 'Adam le Vieleur,' corrupted to 'Violer,' then 'Fidler', who owned the ferry rights.

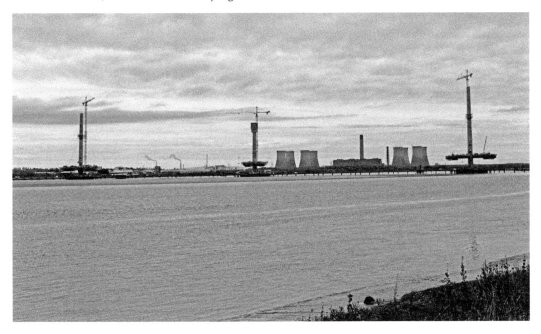

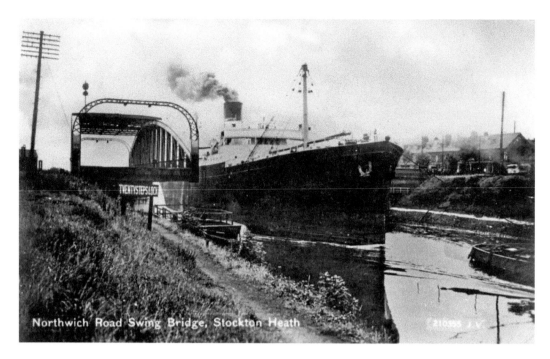

Northwich Road Swing Bridge, Stockton Heath

Northwich Road (A49, London Road) Swing Bridge, Stockton Heath, *c.* 1930
Looking north across London Road Swing Bridge at Stockton Heath, with the clock tower of the former Greenall's Brewery, now a retail development, just visible at the far end of the bridge in 2016. The turning mechanism of the swing bridge has been known to break down in recent months, causing traffic chaos. Twenty Steps Lock (signposted left *c.* 1930) is now disused. Towards Runcorn is the A5060, Chester Road Swing Bridge (*see* inset) with Warrington Wharf, Walton Cut and Lock, and a sand berth between the bridges.

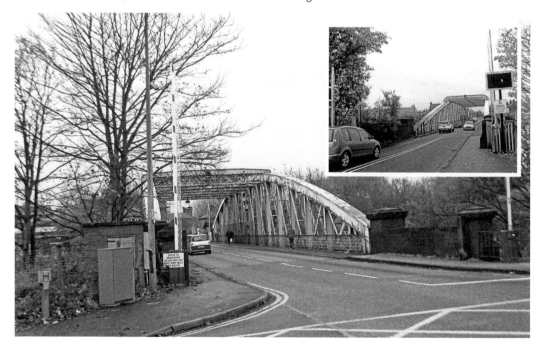

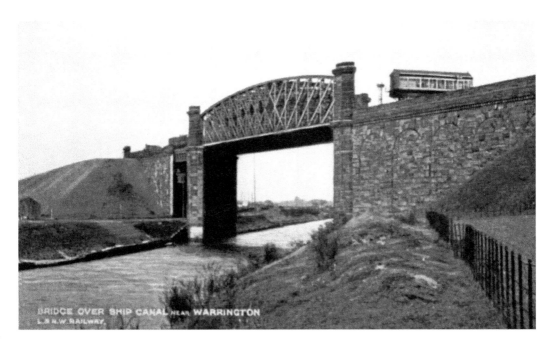

L&NWR and GWR Bridge over the Manchester Ship Canal, Acton Grange, near Warrington, *c.* 1905

Acton Grange Viaduct was constructed 1893, with a wharf between the viaduct and Moore Lane Swing Bridge (*see* inset). Randle sluices and the Vyrnwy pipeline, beneath the canal, lead towards Runcorn. During construction of the canal a navvy's village, complete with accommodation huts, was situated at Acton Grange; entire families lived in these settlements. Working and living conditions could be basic. There was a smallpox outbreak around 1892, as well as the usual infectious diseases and work-related injuries. A smallpox hospital was located nearby.

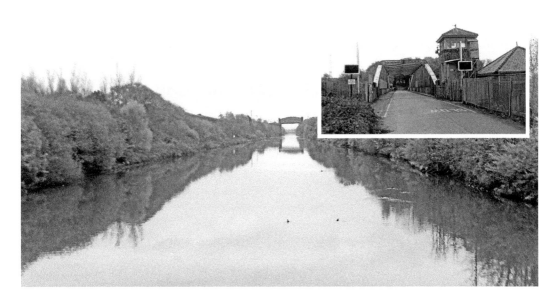

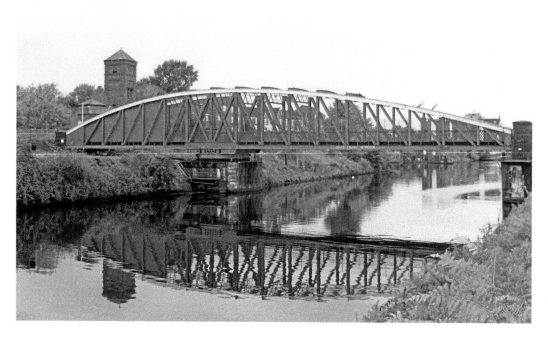

Old Quay Swing Bridge and Old Quay, Runcorn, 2016
The disused Old Quay Lock (*see* the centre of the bottom image) was the terminus of the St Helens Canal. Opposite (now flats) were Old Quay workshops, the canal's maintenance department and the base for its silt dredgers. The Old Quay Swing Bridge is the last on the canal, designed by Edward Leader Williams. Nearby is Wigg Island Nature Reserve, once Wigg Wharf, where Guinness was imported from Ireland and the site of a First World War mustard gas factory, recently decontaminated for the construction of the new Mersey Gateway Bridge.

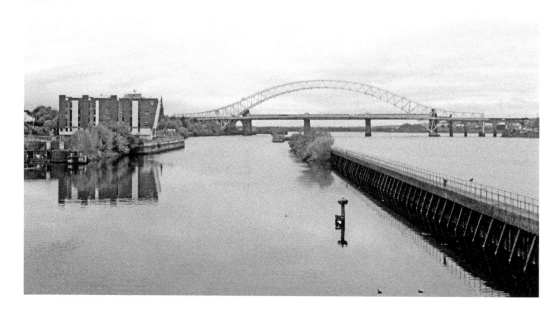

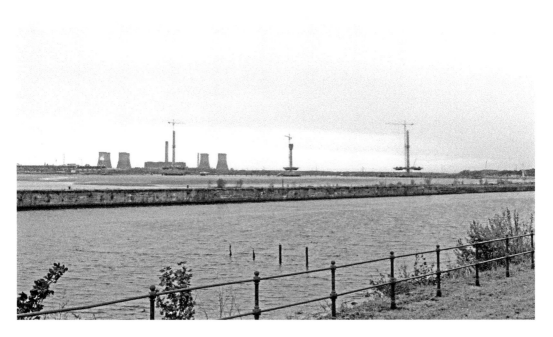

Mersey Gateway Bridge, Fiddler's Ferry Power Station and Old Quay, Runcorn, 2016
Opening in autumn 2017, a second road crossing over the Mersey has been long sought after by Halton Borough Council, as the Silver Jubilee Bridge handles ten times the amount of weekday traffic than it was originally designed to take. The new bridge will cross the river and canal 1.5 kilometres (0.9 miles) to the east of the Silver Jubilee Bridge. It will be a tolled crossing, with a 60mph speed limit and three lanes. It is hoped to stimulate new investment and ease road congestion.

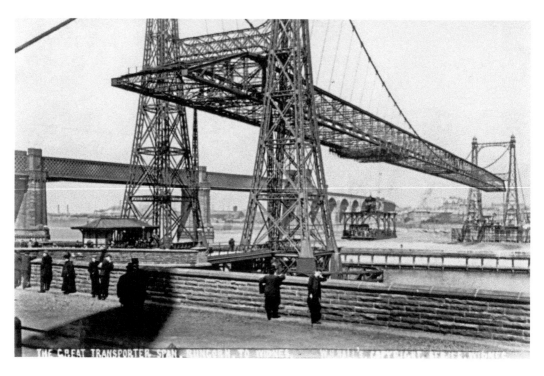

The Great Transporter Span, from Runcorn to Widnes, _c._ 1910
Constructed in 1901–05 and operating from 1905–61. Built by the Widnes & Runcorn Bridge Co. (formed 1899), the transporter was owned and operated by Widnes Borough Council. It allowed carts and motorised traffic to cross, using electrical power. It took four minutes and is estimated to have carried over 1 million foot passengers and a quarter of a million vehicles each year. It was the longest continually operating transporter in the world, with the largest UK span at 330 metres (1,000 feet).

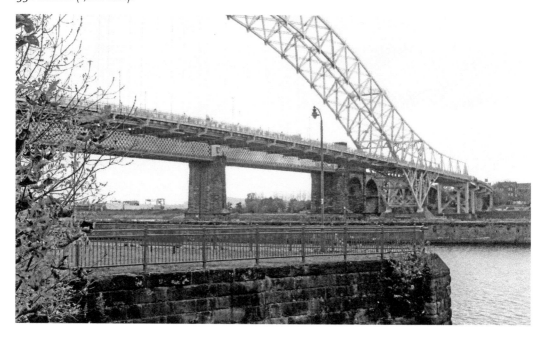

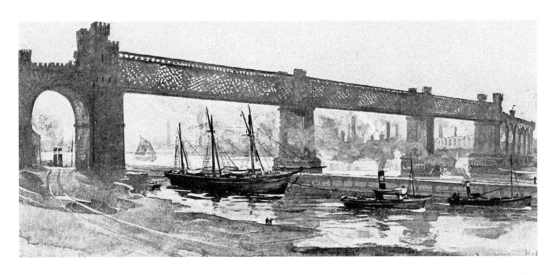

The Manchester Ship Canal under Britannia Railway Bridge, Runcorn, c. 1900, and MSC *Buffalo*, 2016

It was constructed from 1863–68 and opened for traffic on 10 October 1868 and, like the Silver Jubilee Bridge, it is Grade II listed. It was built for the L&NWR, to a design by William Baker, chief engineer of the railway company, and was on the line between London, Crewe and Liverpool. It is part of the West Coast mainline. The bridge is locally known as the Queen Ethelfleda Viaduct, as part of it is built on a Saxon site; however, it is more commonly called the Britannia Bridge.

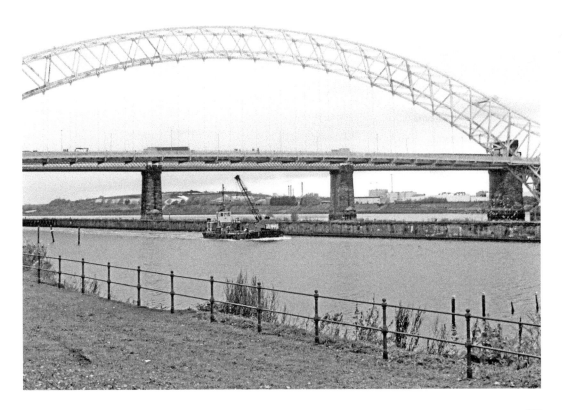

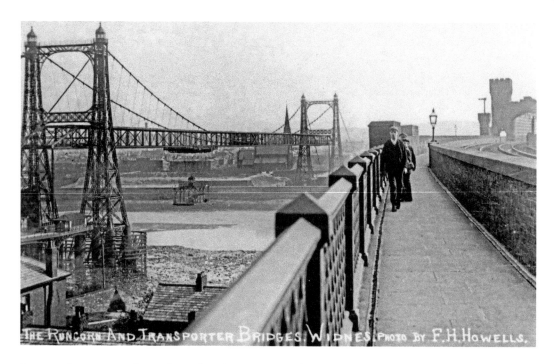

Runcorn Transporter from the Pedestrian Footway (closed in 1965) of the Britannia Railway
Bridge, *c.* 1910

On 22 July 1961, the transporter made its last journey from Widnes to Runcorn. The increased
volume of motor traffic meant it became obsolete and was demolished, replaced by a new
high-level, single-arch bridge next to it. Runcorn Bridge, constructed in 1956–61, crosses the
River Mersey and Manchester Ship Canal at Runcorn Gap. It carries the A533, and was officially
opened by Princess Alexandra on 21 July 1961. It was widened around 1977, and then renamed
the Silver Jubilee Bridge, honouring the Queen's Silver Jubilee.

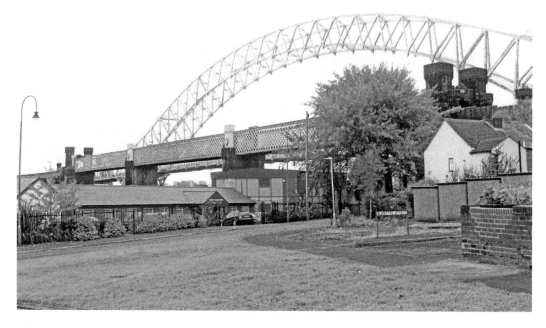

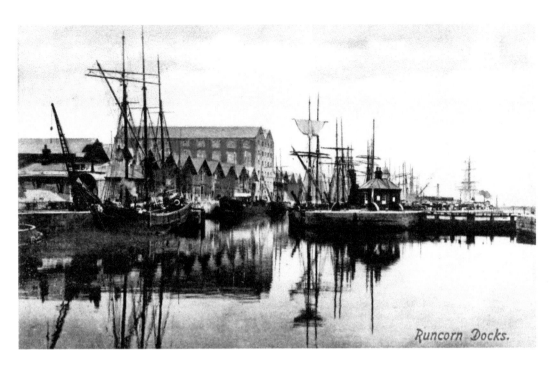

Runcorn Docks, *c*. 1900 and Bridgewater Lock, 2016

The Castner Kellner chemical plant, where there is access to several canals, gives way to Weston Marsh Lock, the River Weaver and sluices, Weston Point, Frodsham and Ince Marshes, and Ince Power Station. The canal curves in an 'S' bend from Runcorn, with larger ships, once assisted by tugs to negotiate a combination of this curve, crosswinds and water running off the River Weaver. Runcorn Docks are on the left (off camera) of the 2016 photograph, as well as a logistics terminal, and Bridgewater House, once the canal's Port Division Office.

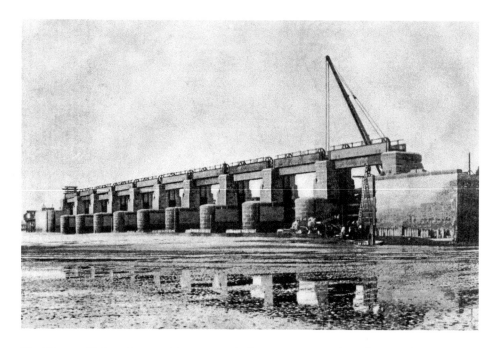

The Weaver Sluices Between Runcorn and Ellesmere Port, and Eastham Lock Gates, 1893
These sluices allow excess floodwater from the River Weaver, which enters the Manchester Ship Canal, to drain from the Manchester Ship Canal and into the Mersey Estuary. Passage through this section of the Manchester Ship Canal sometimes necessitated the assistance of a tug, the force of the outflow from the River Weaver often pushing a vessel towards the far bank. The lock gates at Eastham are 15.24 metres (50 feet) high and are constructed of Greenheart wood, a tropical hardwood particularly resistant to marine organisms.

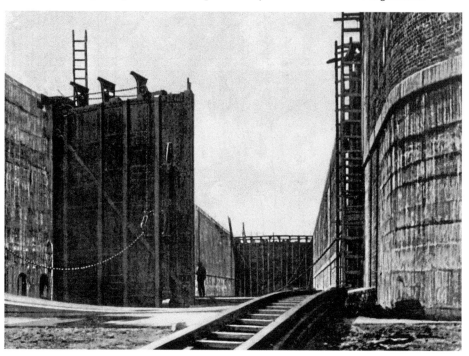

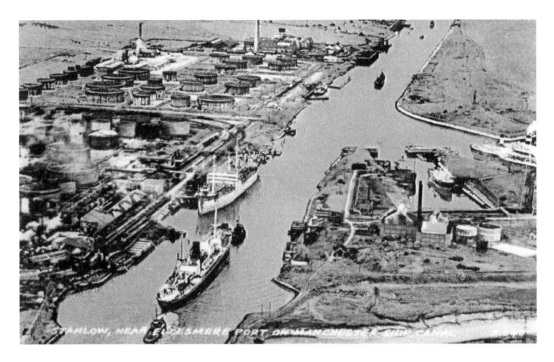

Stanlow Oil Refinery, near Ellesmere Port, *c.* 1960

Stanlow's tanker berths (2016 image, left) were constructed in 1922, with production at a small bitumen plant from 1924. The installation continued to grow, with Stanlow & Thornton railway station opened in 1940. In the 1970s, an oil pipeline from Amlwch, on Anglesey, to Stanlow was constructed, with crude oil pumped ashore from tankers moored at deep-water pontoons. Discontinued by 1990, the Tranmere Oil Terminal now receives supplies, which are then transferred to Stanlow via a 24-kilometre (15-mile) pipeline.

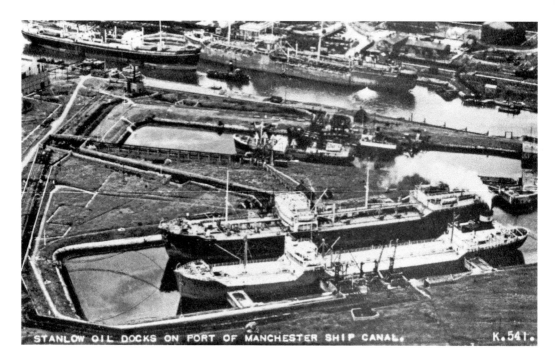

STANLOW OIL DOCKS ON PORT OF MANCHESTER SHIP CANAL. K.541.

Stanlow Oil Docks on Port of Manchester Ship Canal, 1951 and Stanlow Island (2016 image, left)
The larger dock was opened 26 May 1933 by the Hon. O. Stanley, Minister of Transport. The refinery is situated on the south bank of the Manchester Ship Canal, which is still used to transport oil and chemicals. Stanlow Priory was once located on the island opposite and a private ferry stage is here. Stanlow is the second largest oil refinery in the United Kingdom and is linked to the national oil pipeline network. Locally, there is also a pipeline for jet fuel to Manchester Airport.

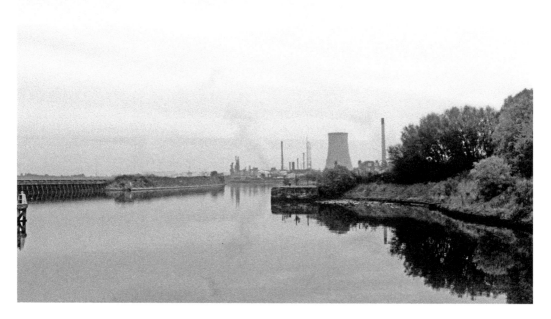

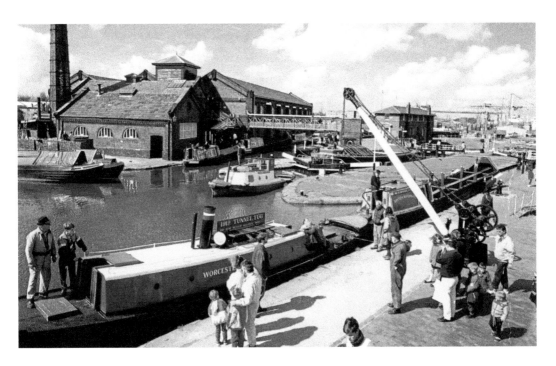

National Boat Museum and Dock Cranes, Ellesmere Port, *c.* 1980

The National Boat Museum is located at the entrance to the Shropshire Union Canal (*see* inset), which once ran directly into the Mersey Estuary. Telford's original quay consisted of several warehouses and basins, now surrounded by residential properties. The best known were those constructed to store clay for the potteries, and other products needing shelter from the elements. They were damaged by fire in May 1970 and demolished. The image from around 1980 shows Ellesmere Port dock cranes beyond the museum. The dock is now on the left.

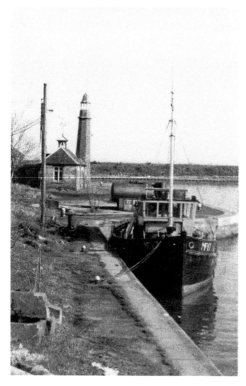

Telford's Lighthouse, National Boat Museum, Ellesmere Port, *c*. 1970

Ellesmere Port container terminal was built in 1970 on North Quay, handling container ships and importing and exporting cars. Adjacent to the container terminal is the Shropshire Union Canal, with Thomas Telford's original lighthouse, built in 1828, standing over the entrance locks. It is the only lighthouse on the British inland waterways system. Originally, the canal ran into the Mersey Estuary, then later the ship canal. Towards Stanlow is a concrete dam, the first location at which water from the Mersey Estuary was admitted to the canal.

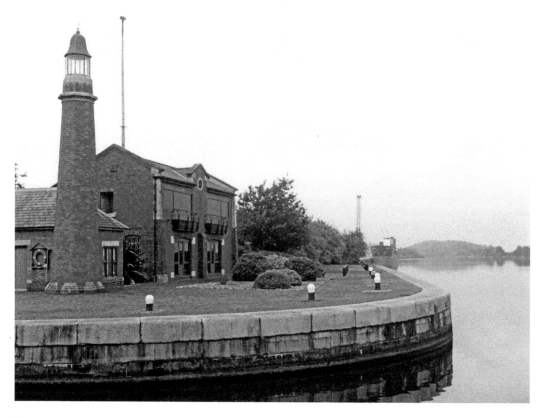

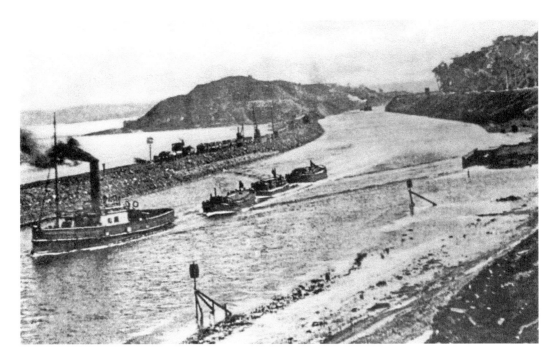

Above Eastham, Just After Opening, *c.* 1896

A tug tows three canal barges and Mount Manisty can be seen in the background, made from excavations and named after the construction engineer. It is now a nature reserve. On the eastern bank, there are unloading berths for a paper mill, next to Vauxhall Motors Ellesmere Port plant. The canal is separated from the River Mersey here by a narrow strip of land, Pool Hall Bay Embankment, with a 'siphon' taking a small river beneath it, one of several along the 57.9-kilometre (36-mile) route.

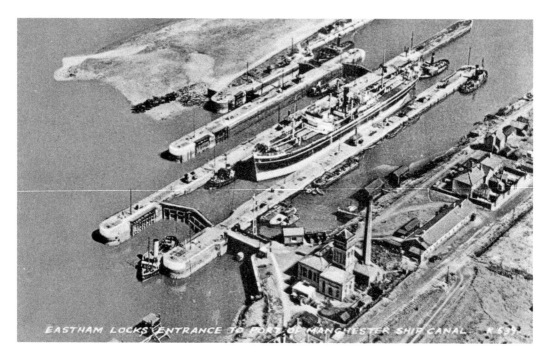

Eastham Locks, *c.* 1960

Eastham Locks mark the exit to the Manchester Ship Canal, leading into the tidal Eastham Channel, which in turn gives access to the Mersey Estuary. They are the only ones with three operational locks, as opposed to two elsewhere. The fourth lock is the disused barge lock. The three operational locks include two sets of ship locks, with intermediate gates to save water for smaller vessels, and, downstream from the other locks and the largest, a lock for oil tankers to the Queen Elizabeth II Oil Terminal.

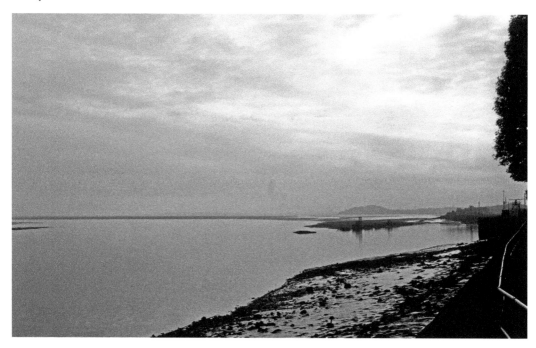

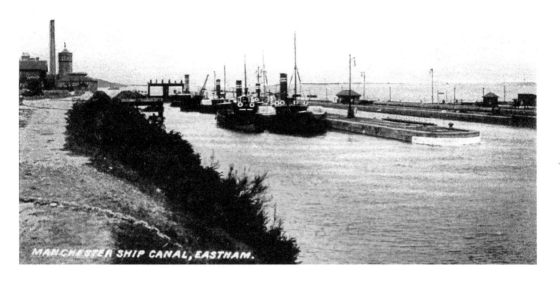

MANCHESTER SHIP CANAL, EASTHAM.

Eastham Locks, *c.* 1900

On the left of this seaward image of Eastham Locks is the Eastham Ferry Hotel. The owner of the ferry, Thomas Stanley, built the hotel and pleasure gardens, which became very popular and were further boosted by the opening of the Manchester Ship Canal in 1894. By the 1930s the ferry had stopped, the pleasure gardens declined and the pier was dismantled. However, it is once again a popular recreational area, together with the Tap public house (*see* inset) and coastal walks.

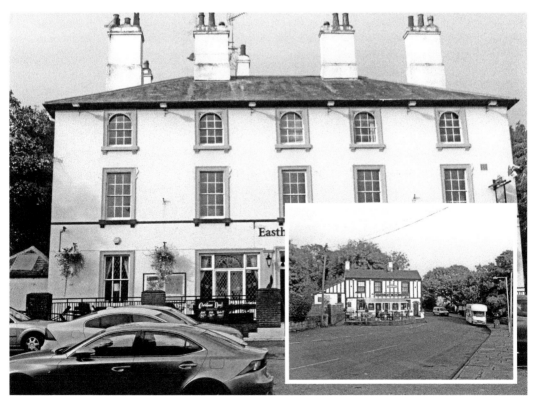

GREETINGS FROM

WHITBY ROAD

RIVACRE BATHS

CHRIST CHURCH

ELLESMERE PORT

QUEEN ELIZABETH 11 DOCK

CORPORATION OFFICES

EP.58F.

Queen Elizabeth II Docks, Eastham (bottom left), *c.* 1960, and Eastham Locks, *c.* 1894
The dock opened on 19 January 1954. Building began in 1949, with its entrance constructed just before the gates of the Eastham Locks. The new dock solved the problem of gaining access to the canal for larger oil tankers. Four berths handled tankers up to 30,000 gross tons. Eastham Oil Terminal was built nearby. However, the demand for oil continued to grow, with a new facility at Tranmere opened on 8 June 1960. This could handle vessels of 65,000 tons, with oil piped to Stanlow.

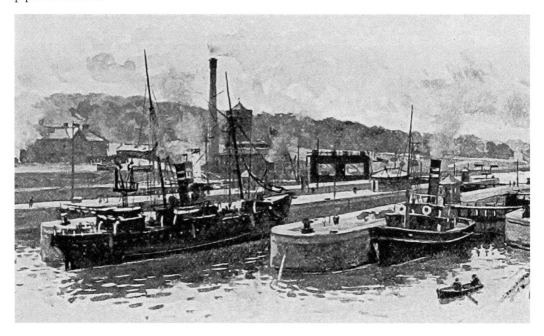

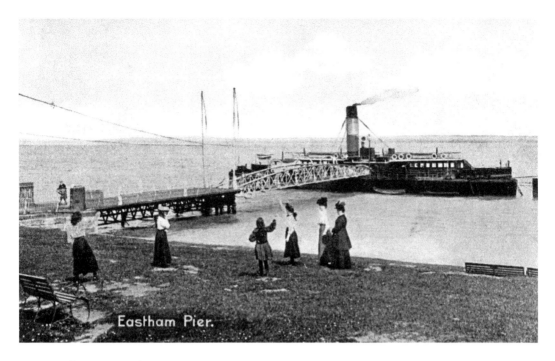

Eastham Pier.

Eastham Pier and Ferry, 1901

A ferry service across the River Mersey between Eastham and Liverpool began in the Middle Ages, operated by monks from St Werburgh Abbey. By the end of the eighteenth century, up to forty coaches a day were using the newly constructed pier. Paddle steamers were brought into service in 1816, replacing sailing boats, but decline set in around 1840 with the construction of railways. In 1846, Thomas Stanley built the Eastham Ferry Hotel and pleasure gardens. The last paddle steamer crossing was in 1929.

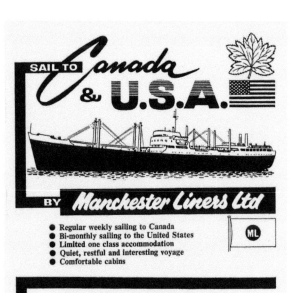

Manchester Liners Advertisement and Manchester Venture, 1964

Manchester Venture was in service in 1956 and was sold in 1961. In 1972, the vessel experienced a cargo explosion and fire on board, resulting in the former *Manchester Venture* being beached, an inauspicious end. The second *Manchester Venture* entered service in 1977 and was sold in 1980, being broken up as recently as 2002. The Manchester Liners advertisement of 1964 announces passenger berths aboard the company's flagship sailings to the United States and Canada, reflected in the names along Salford Quays today.

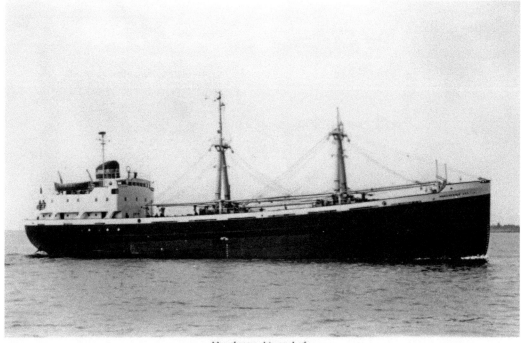

Manchester Liners Ltd.
M.V. " MANCHESTER VENTURE ". gross tonnage 1661

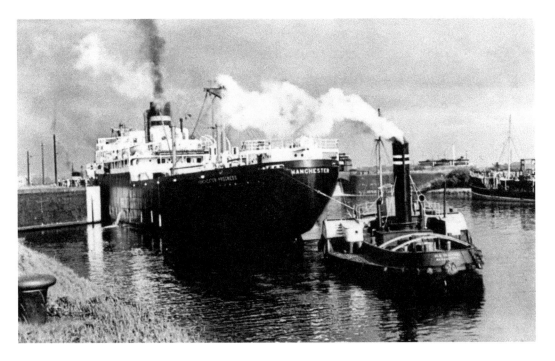

SS *Manchester Progress* and Tug, *c.* 1938

Manchester Progress was built in 1938 by Blythswood, with a single screw turbine engine. The vessel was coal-fired, had a maximum speed of 13 knots and was later fitted with radar and automatic stokers. Service ended on 17 January 1966, *Manchester Progress* being sent to the breakers the following month. The second *Manchester Progress* carried this name from 1967–72, then was converted into a container ship and renamed *Manchester Concept*, which was sold to Hong Kong in 1980.

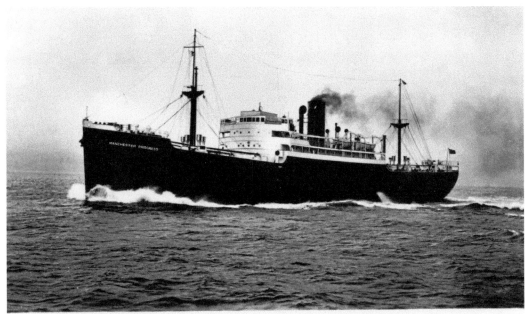

MANCHESTER LINERS LTD. S.S. "MANCHESTER PROGRESS"

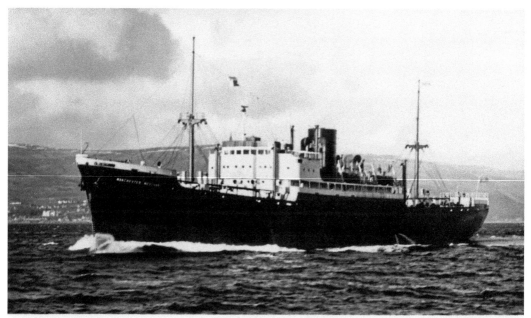

MANCHESTER LINERS LTD. S.S. "MANCHESTER MERCHANT" Gross Tonnage 7651

MV *Manchester Faith* and SS *Manchester Merchant*, c. 1965

Manchester Faith was built in 1958, exclusively for the Great Lakes service. It was sold in 1969 and broken up in 1982–83. There were two more *Manchester Faith* charter vessels in the 1970s/80s. The first *Manchester Merchant* was built in 1900 and was scuttled when her cotton cargo caught fire in Dingle Bay, Eire, in 1903. The second, built in 1904, was broken up in 1933. The third, built in 1940, was torpedoed and sunk in 1943, with thirty-six lost. The fourth, built in 1951, was sold in 1967 and abandoned, presumed sunk, due to fire in 1972.

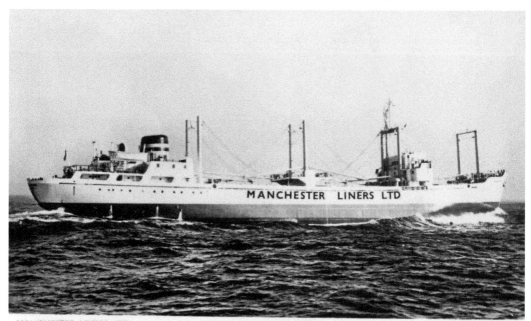

MANCHESTER LINERS LTD. M.V. " MANCHESTER FAITH " Gross Tonnage 4459

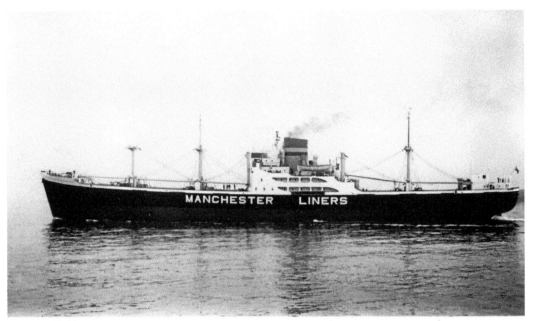

MANCHESTER LINERS LTD. S.S. "MANCHESTER EXPORTER" Gross Tonnage 7506

SS *Manchester Exporter*, c. 1967

Built in 1918, the first *Manchester Exporter* was originally *Rexmore*, owned by Johnson Line UK. It became SS *Manchester Exporter* in 1929 and was sold to Hong Kong in 1947. After several further transfers of ownership, it was broken up in June 1958, at Osaka, Japan. The second *Manchester Exporter* was built in 1952, being transferred to Manchester Liners in 1965 from Cairn Line. In 1970, the vessel was sold to Greece. The name 'Exporter' signifies Manchester's place in international trade.

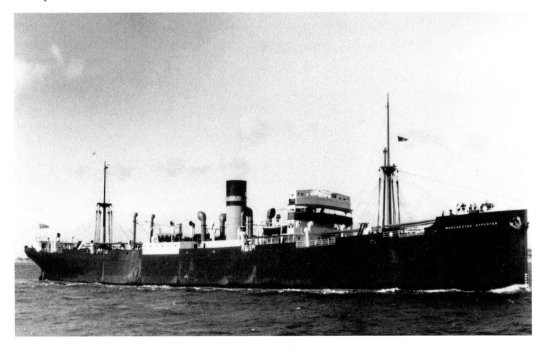

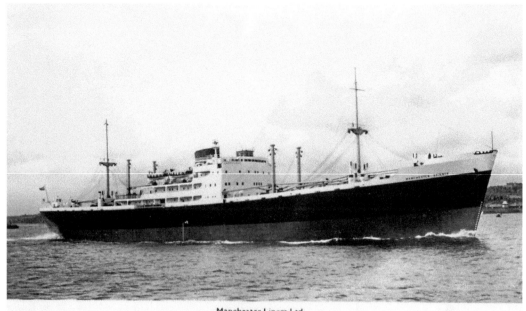

Manchester Liners Ltd.
S.S. "MANCHESTER SPINNER"

SS *Manchester Spinner*, 1961, and Containership, Manchester Concorde, 1969

Built in 1903, the first *Manchester Spinner* was torpedoed and sunk near Malta in 1918. The second *Manchester Spinner* began service as *Grampian Range*, for Furness Withy UK, in 1918 and entered service with Manchester Liners in 1921. In 1944, the vessel was scuttled as part of harbour number four, off the Juno beachhead, Normandy. The third *Manchester Spinner* (shown above) was built in 1952 and sold to Greece, in 1968. In 1961, Montreal and Quebec were destinations. *Manchester Concorde* was built in 1969 and broken up in 1983.

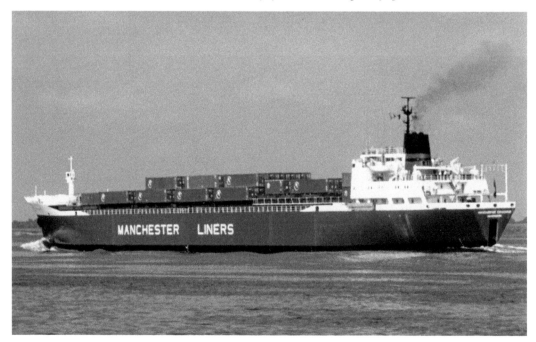

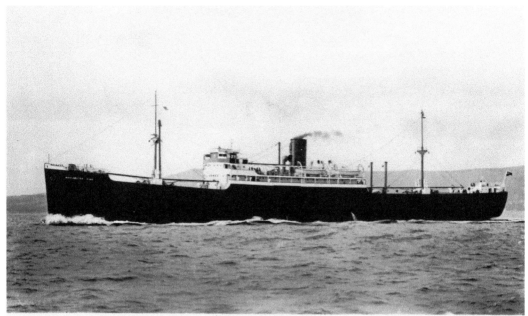

MANCHESTER LINERS LTD. S.S. "MANCHESTER PORT" Gross Tonnage 7170

SS *Manchester Port, c.* 1965

The first *Manchester Port* was built in 1899 and sold to Houston Line in 1911; the second *Manchester Port* was built in 1904 and sold to Hamburg in 1925; the third *Manchester Port* was built in 1935 and was broken up in Bilbao, January 1965; and the fourth Manchester Port was built in 1966 and sold to Yugoslavia in 1971. The name 'Manchester Port' is of major significance in identifying Manchester as a seagoing port for the first time in its history.

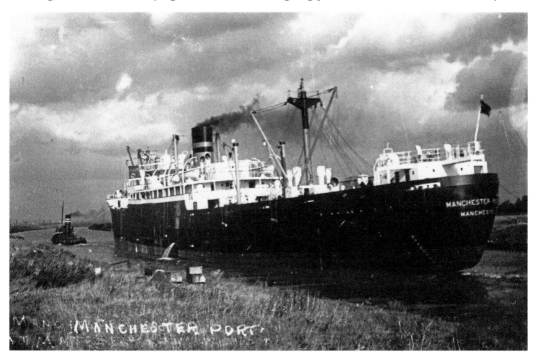